C000199076

A CENTURY OF
AYLESBURY

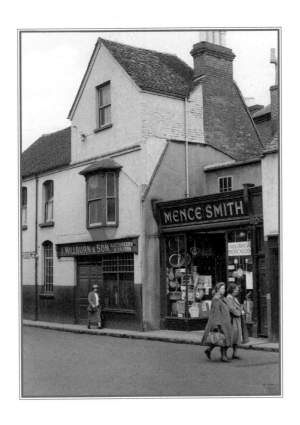

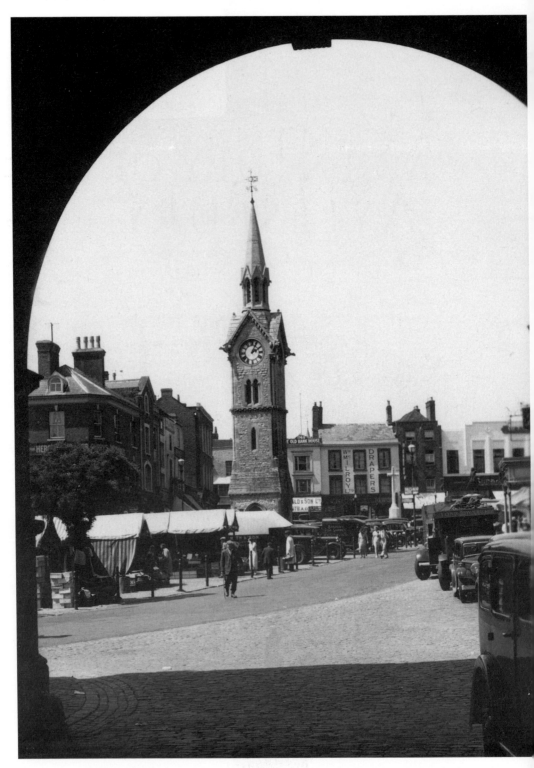

Market Square, viewed from the arches of the Town Hall, 1938. *(K. Vaughan)*

BRITAIN IN OLD PHOTOGRAPHS

A CENTURY OF
AYLESBURY

KARL VAUGHAN

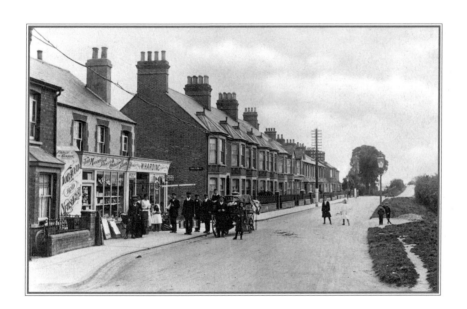

First published in hardback in 2002 by Sutton Publishing.
This updated paperback edition first published in 2011 by

The History Press
The Mill, Brimscombe Port
Stroud, Gloucestershire, GL5 2QG
www.thehistorypress.co.uk

© Karl Vaughan, 2002, 2011

The right of Karl Vaughan to be identified as the Author
of this work has been asserted in accordance with the
Copyrights, Designs and Patents Act 1988.

All rights reserved. No part of this book may be reprinted
or reproduced or utilised in any form or by any electronic,
mechanical or other means, now known or hereafter invented,
including photocopying and recording, or in any information
storage or retrieval system, without the permission in writing
from the Publishers.
British Library Cataloguing in Publication Data.
A catalogue record for this book is available from the British Library.

ISBN 978 0 7524 5810 6

Typesetting and origination by The History Press
Printed in Great Britain

CONTENTS

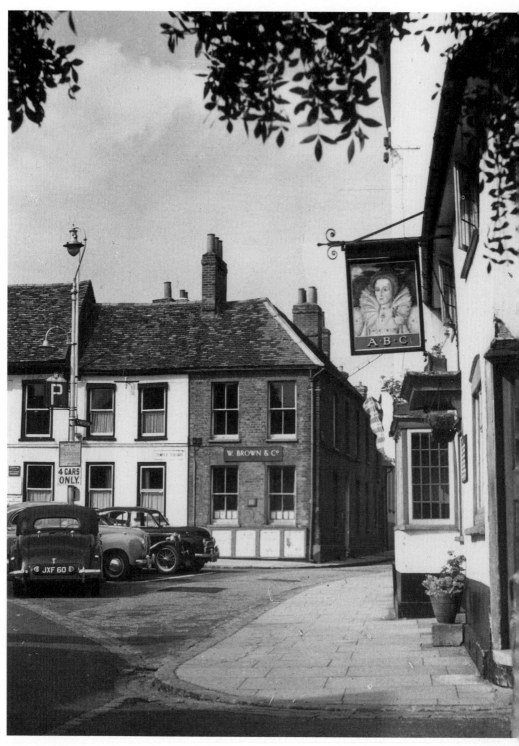

A view of Temple Square looking towards Church Street in the mid-1950s. On the right is the Queen's Head pub. *(M. Sale)*

INTRODUCTION

At the turn of the twentieth century Aylesbury was a busy market town with lots of people coming here to trade and to buy and sell livestock. Although technology has changed over the years, Aylesbury remains busy and while many shops and businesses have come and gone, the town has continually expanded to keep pace with the population increase. With this influx of people from other towns and countries the Aylesbury accent and dialect has virtually disappeared. It can still be heard in the voices of the older natives, but even those intonations are quite diluted. During the research of this book I was fortunate to talk with a man who was born in Aylesbury in 1905 and he had quite a strong accent. He recalled being at the unveiling of the John Hampden statue in 1911 – a long time ago indeed. To give an example of what the accent was like, I asked him if he remembered the Crown Hotel at the top of the High Street. He replied, 'Oh I remember the Crane,' Crane being how he pronounced the word 'Crown'. It was a rare treat to hear. After reaching the age of 100, the man sadly died in 2005.

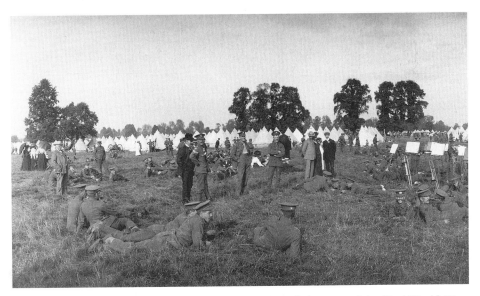

Army manoeuvres on the outskirts of Aylesbury around the time of the First World War. (*R.J. Johnson*)

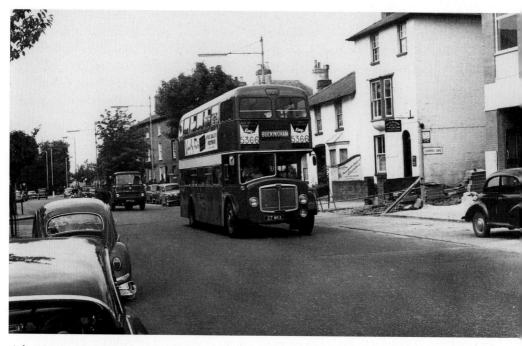

A bus coming into town on Buckingham Street, 1965. On the right, construction of Heron House is nearing completion. *(D. Bailey)*

Other things have changed since 1900 too. There have been many controversial schemes to improve the look and layout of the town. The most profound change to the Aylesbury skyline was made in the 1960s when a huge area containing old streets and buildings was mercilessly swept away to be replaced by Friars Square shopping centre and the new county council offices. This was the beginning of the end for an Aylesbury that was full of character and charm. Many roads were widened and the countryside was encroached upon with new housing estates cropping up.

The Aylesbury of 1900 was not only a market town but an industrial workhorse. Major factories established in the Victorian period such as the printing works of Hazell, Watson & Viney, the condensed milk factory of Nestlé and the Rivet works employed hundreds of people. Many spent most of their working lives in these places.

The volume of people visiting Aylesbury at that time was quite a lot so the town had to cater for them all. Many pubs and inns were dotted about the town – by 1900 there were about eighty. For instance, in the Market Square there were the King's Head, George Hotel, Crown Hotel, Bull's Head Hotel, Green Man, Six Grapes, Bell, Greyhound, Coach & Horses, Cross Keys and the White Horse. An amazing number indeed. A hundred years later the number had decreased to about forty in the whole town. Aylesbury expanded in the 1920s when the Southcourt estate was started. Slum clearances were underway too and places such as Upper Hundreds and Spring Gardens (off White Hill) were levelled. Some of the inhabitants were moved to new houses in Southcourt or Oxford Road.

Already by that time, plans were drawn up to improve and modernise the town. Various schemes were dreamt up but by the late 1930s everything was shelved because of the outbreak of war. Aylesbury escaped much of the destruction inflicted on the major cities but it did have one bomb fall in a built-up area. This was a parachute mine which fell to the rear of Walton Pond, sadly destroying a lovely old building called Walton Grange. Also, many properties were severely damaged and one man lost his life. Other bombs did fall over the town, but were less destructive.

With the war over, attention again was brought to the plans for modernisation. In the second half of the 1950s buildings were being earmarked for demolition, the old public baths in Bourbon Street being one of the first to go. The following decade would see a transformation like never before. Huge areas of the town centre were swept away, a ring road was constructed to encircle Aylesbury and new county council offices were built, as well as Friars Square shopping centre and the adjacent multi-storey car park. This in effect created a new Aylesbury and gone was the charm of that old market town. In conjunction with the changes to the town centre, new housing estates were cropping up on farmland such as Elmhurst, Quarrendon and Bedgrove. Many of these new houses were occupied by Londoners seeking a new life in the country – quite a change from the crowded city streets.

A growing population needed places of entertainment and in the 1960s there was plenty going on in the town. The Borough Assembly Hall in Market Square was the main venue for popular acts of the day and by the end of the decade the Friars Club was established by David Stopps and Robin Pike. It started in a little hut in Walton Street but soon moved into the Borough Assembly Hall and later to the Civic Centre when that opened in 1975. This was to mark a golden era for the town in the 1970s and '80s. Aylesbury saw acts such as David Bowie, Genesis, Roxy Music, U2 and the town's very own band, Marillion, appearing at its various venues. In the mid-1970s Market Square was host to an open-air concert called the 'Hobble on the Cobbles' which featured local talent such as John Otway. The event only lasted a short time but has recently been revived and is a great success.

The 1980s and '90s saw many more changes in the town. The once great employer of Aylesbury, printers Hazell, Watson & Viney, closed leaving the site clear for the building of the Tesco supermarket on Tring Road. Friars Square underwent quite a major redevelopment with the market area having a roof installed thus making the shopping centre a totally indoor place to shop. The market itself moved back to Market Square where it belongs. The cattle market closed and after a few years of the site being used for a car park, the site was redeveloped and a new cinema was built. A couple of new 'villages' were built on the outskirts of town, namely Watermead and Fairford Leys. Who knows what the next century will bring?

Karl Vaughan, 2011

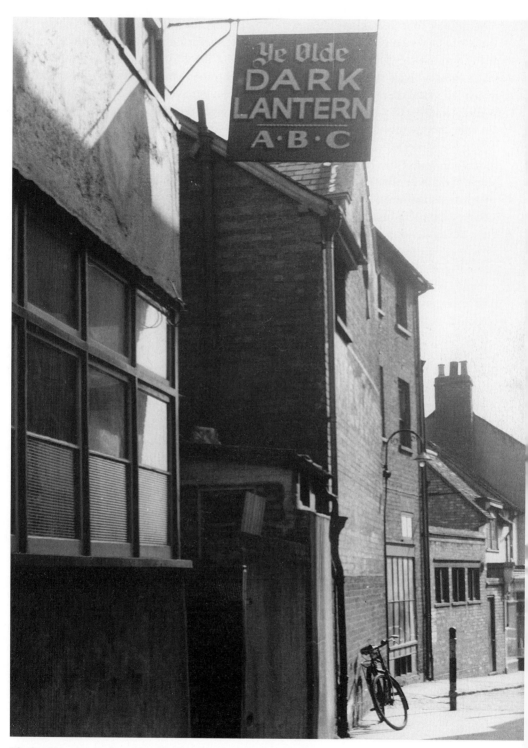

The Dark Lantern pub in Silver Street, early 1950s. The building with the bicycle leaning against it is Jones & Cocks, ironmongers. *(R.J. Johnson)*

1

THE FIRST
TWENTY YEARS

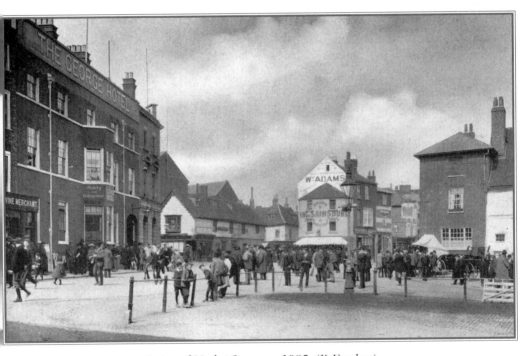

A view of Market Square, *c.* 1905. *(K. Vaughan)*

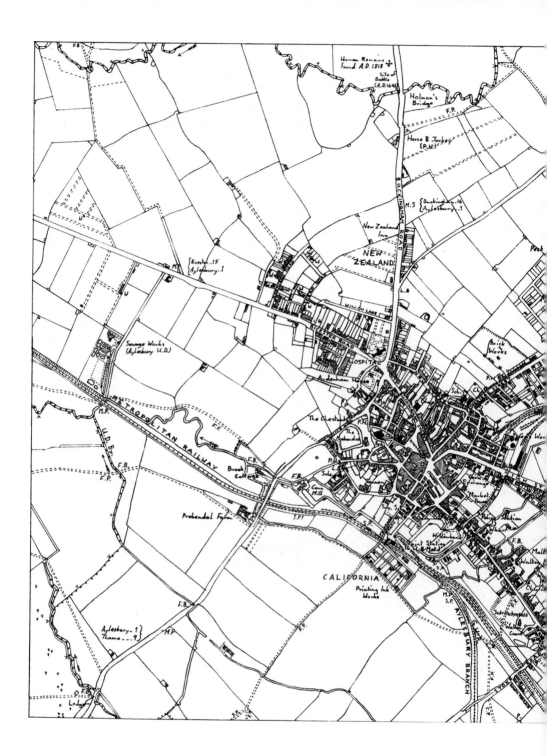

12

A map of Aylesbury
in 1900 which shows
clearly the amount
of land that was still
undeveloped on the
outskirts of the town.
Many of the inhabitants
of Aylesbury were living
above their places of
work but there were
many slum areas in the
town, too; in particular,
Spring Gardens off White
Hill (the top of Oxford
Road), Upper Hundreds,
and Prospect Place
which was off Walton
Street. The LNWR
branch railway stretches
off towards Cheddington
on the right – a railway
that disappeared in the
1960s. *(K. Vaughan)*

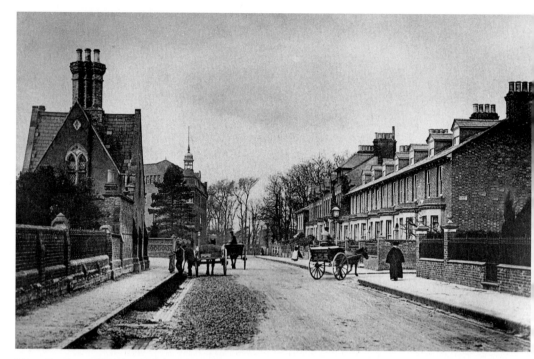

Tring Road, *c.* 1900. On the left is the cemetery, which was opened in 1857. Further down the road is the large factory of printers Hazell, Watson & Viney. *(M. Sale)*

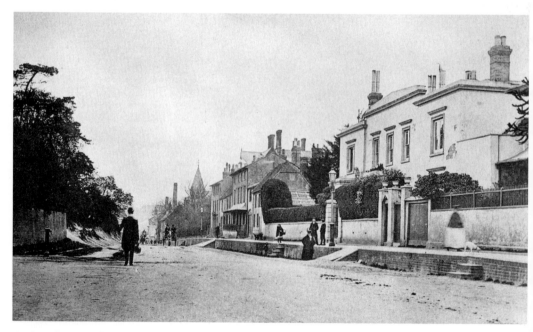

A view down Walton Street, *c.* 1900. The buildings on the right still exist today but now front a dual carriageway. Behind the hedge on the opposite side of the road was Walton Court Farm. Adjacent to the farm was a piece of land known locally as 'Humpy Bumpy Field' as it was very undulating. *(M. Sale)*

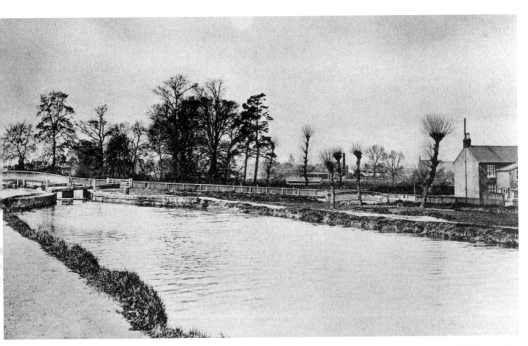

The Grand Union Canal looking towards town with houses in Park Street on the right, *c.* 1900. On the horizon between the trees St Mary's Church can be seen. *(M. Sale)*

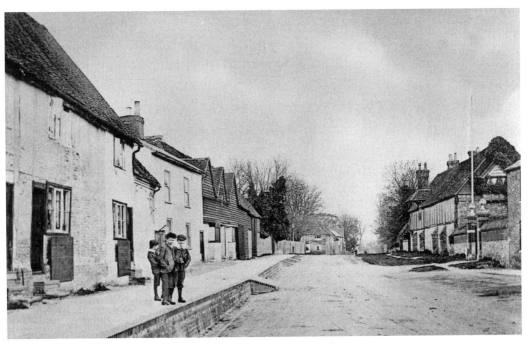

Walton Road, *c.* 1900. The large barn on the right belonged to Walton Grange. Most of the houses seen in this photograph were destroyed by the parachute mine explosion of 1940, which is illustrated in a later chapter. *(M. Sale)*

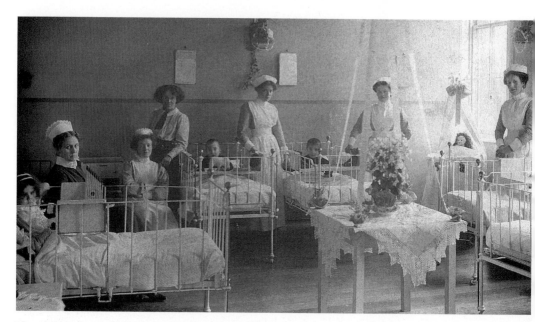

The children's ward of the Buckinghamshire Infirmary, Buckingham Road, *c.* 1900. The hospital was formed in 1832 using an older building on the same site called Dawney's Nursery. It was rebuilt thirty years later and is now known as the Royal Buckinghamshire Hospital. *(R.J. Johnson)*

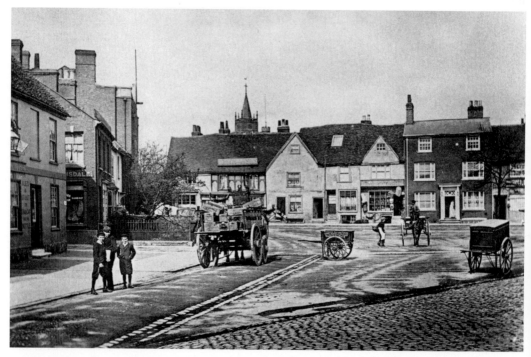

A view of Kingsbury, *c.* 1900. This part of town was originally the site of the ancient manor house for the lords of Aylesbury. Some people call this area Kingsbury Square, which is slightly misleading: although it is an open area, it is actually triangular in shape. *(M. Sale)*

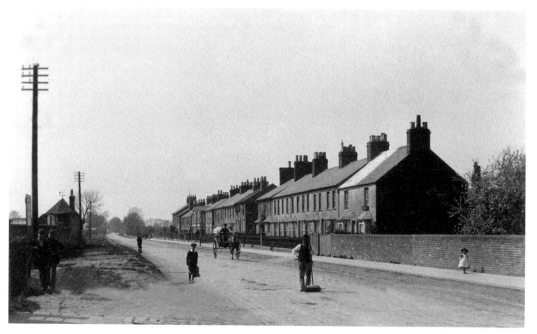

Bicester Road, *c.* 1900. In the centre just behind the horse and cart is the Hop Pole Inn which stands on the corner of Southern Road. Beyond these houses were mainly fields and the road was little more than a dirt track. The turning on the immediate left is Townsend Piece. *(M. Sale)*

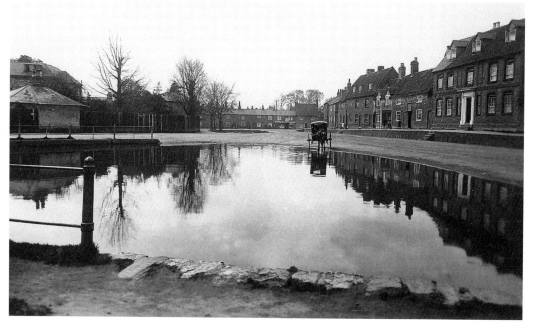

Walton Pond, *c.* 1900. In those days Walton was still regarded as a separate part of the town. It was originally a hamlet on the outskirts of Aylesbury but was eventually encompassed by the ever-growing town. The buildings facing us in the distance are on Wendover Road. *(R.J. Johnson)*

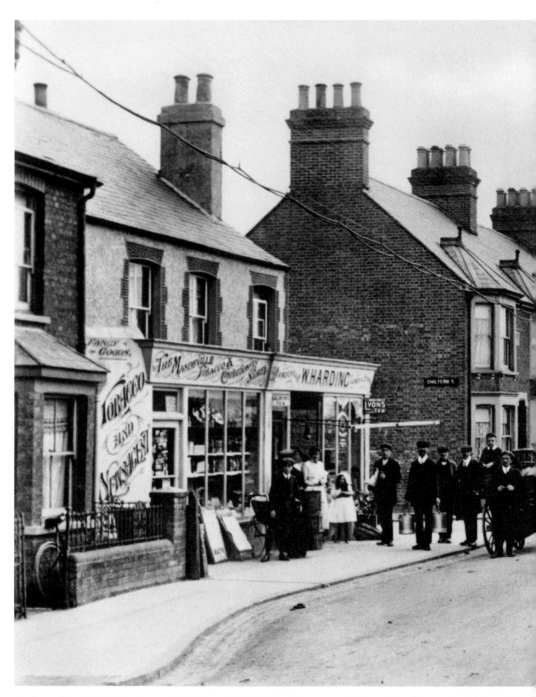

Looking along Stoke Road on a quiet day, *c.* 1900. The entrance to Chiltern Street is seen just beyond the shop. Only a few years before, the street was known as Southern Terrace. In the distance, Old Stoke Road can be seen going over the railway bridge into the countryside – there was no Southcourt in those days. Also of note is the rather elaborate sign-writing on the shop front of the Mandeville Tobacco & Confectionery Stores. Given how busy this road is today, it is unlikely that one would be readily able to take a photograph from the same spot. *(K. Vaughan)*

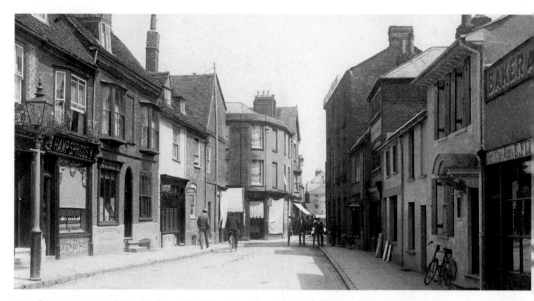

Bourbon Street, *c.* 1900. At the end of the street is a horse and cart waiting outside the grocer and wine merchant, Miles Thomas Cocks. He was from the same family that had the ironmongers business Jones & Cocks which was nearby in Silver Street and Market Square. All the buildings on Cocks' side were demolished in 1964 when the construction of Friars Square shopping centre was begun. *(D. Bailey)*

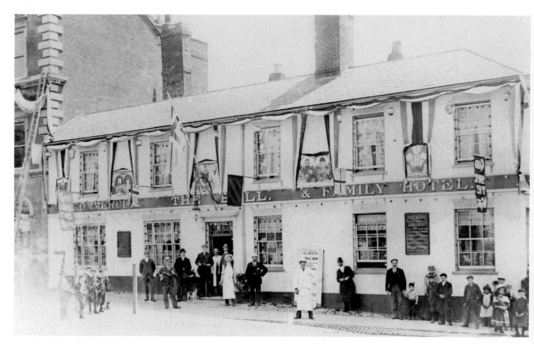

The Bell Hotel decorated for the coronation of King Edward VII in 1902. This is a building which has undergone many alterations over the centuries. It is thought to date from the sixteenth century and probably started life as a tavern. Its façade in this picture appears to date from about 1830. Since then, of course, it has been altered once again, with a new floor being added together with a bay window to the left of the main entrance. *(M. Sale)*

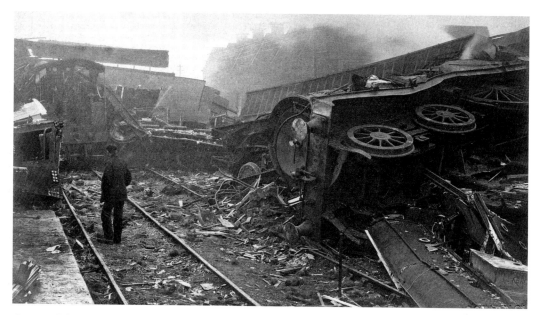

A view of the carnage after the infamous rail disaster at Aylesbury Town station on 23 December 1904. A newspaper train from London left the rails at about 4.30 a.m., while travelling at a speed which was reputed to be 60 miles per hour. It then ploughed on to the neighbouring rails. A parcel train coming from the opposite direction tore into the wreckage, demolishing some of the south end of the platform and bringing down a signal with it. Four men were killed and several injured in the accident. *(M. Sale)*

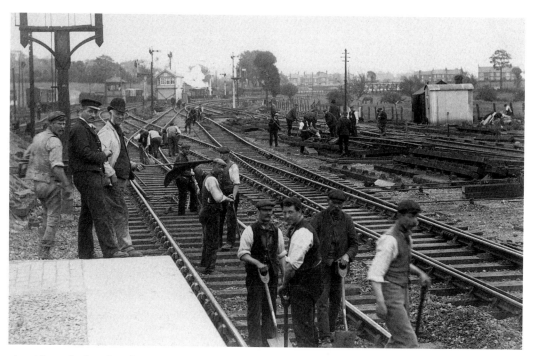

Apart from the fact that the train was going too fast, the turn into the station was too tight, and this caused the train to lose control. After the accident, work began on making the turn less dangerous. *(D. Bailey)*

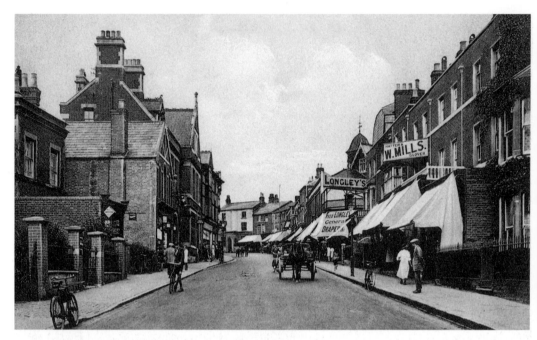

A quaint view of the High Street, *c.* 1905. Almost eighty years since this road was built there were still many properties that were private residences, with walls and railings fronting the street. Seen clearly right of centre is Longley's the draper, a well established firm in the town at that time. *(K. Vaughan)*

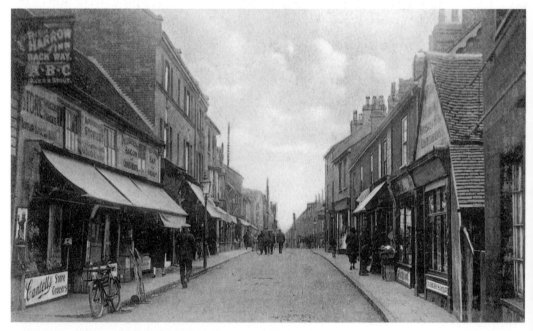

Cambridge Street, *c.* 1905. This end of the street was known as Bakers Lane up until the 1850s when the name largely went out of use. To the left is the rear entrance of the Harrow Inn, a building that still exists today and retains its original name. *(K. Vaughan)*

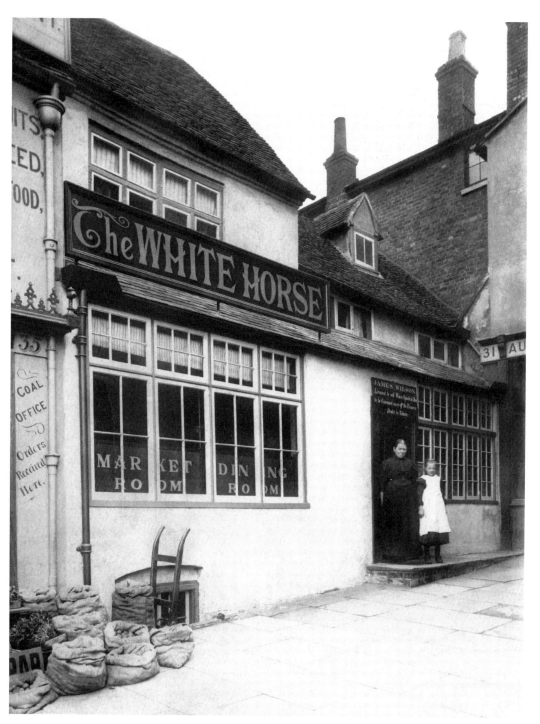

One of Aylesbury's many long-forgotten pubs, the White Horse in Market Square, *c.* 1905. This pub was somewhat tucked away in the corner behind the shop of ironmongers, Jones & Cocks. By the 1920s it had closed. The building survived until the 1960s when it was demolished along with the adjoining buildings to make way for Friars Square shopping centre. *(K. Vaughan)*

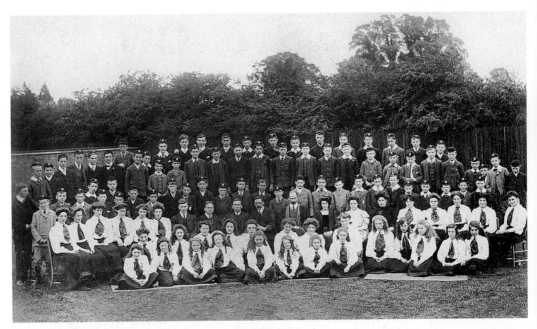

The teachers and pupils of the Grammar School, 1907. This was taken at their new premises on Walton Road, which opened in 1906. The school was originally in Church Street – the old building is now home to the Buckinghamshire County Museum. *(R.J. Johnson)*

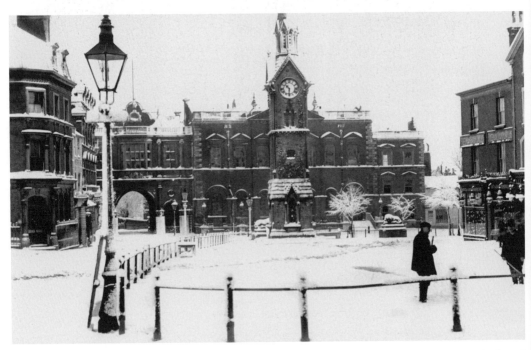

A picturesque view of Market Square covered by snow, 26 April 1908. This freak weather prompted a few of the town's photographers to get their cameras out. The snow only lasted over the weekend and after it had melted there were problems with flooding in low-lying parts of the town. *(R. Adams)*

DUKES & CO.,

GLASS AND CHINA WAREHOUSES,

 4, Market Street,
AYLESBURY. . . .

Established Over a Century.

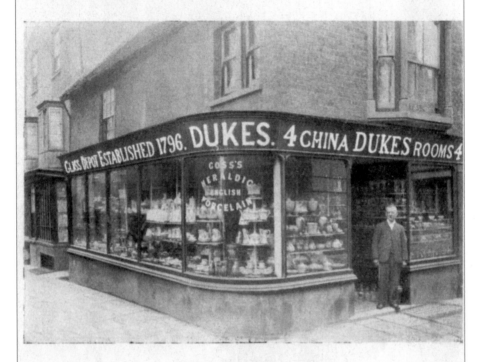

SOLE AGENTS FOR

GOSS' HERALDIC CHINA,

And Coat of Arms Models on Pictorial Post-Cards.

Staffordshire and Worcester China.
Earthenware & Glass of every Description.

Bretby Ware, Terra Cotta,
And all kinds of Garden Pottery.

GOODS LENT ON HIRE. **RIVETING EXECUTED.**

An advert for Dukes china shop in Market Street, *c.* 1908. *(R.J. Johnson)*

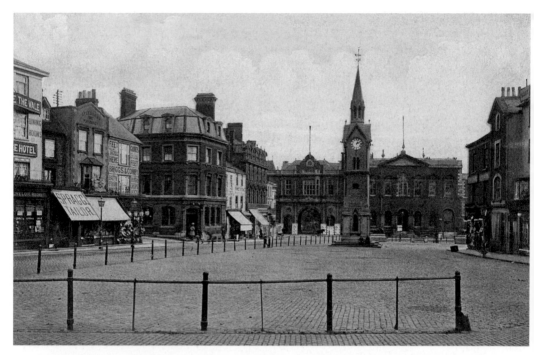

A rather deserted view of Market Square, *c.* 1908. This was taken before any statues were added and of course the war memorial had not yet been built. Today it is impossible to get an unimpaired view like this because the square now has a few trees in the way. *(K. Vaughan)*

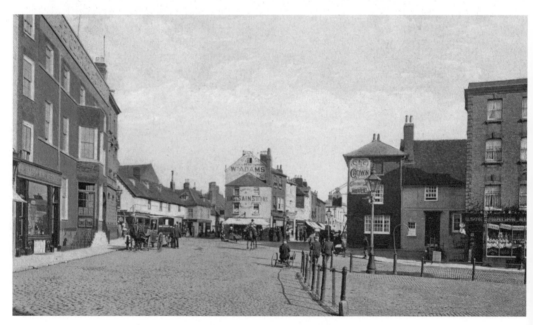

Market Square, *c.* 1908. This is a view of the square before both the John Hampden and Lord Beaconsfield statues were put in place. Just beyond the lamp-post on the right is the Crown Hotel, which had just had its name painted on to the bare brickwork in the typical style of those times. *(K. Vaughan)*

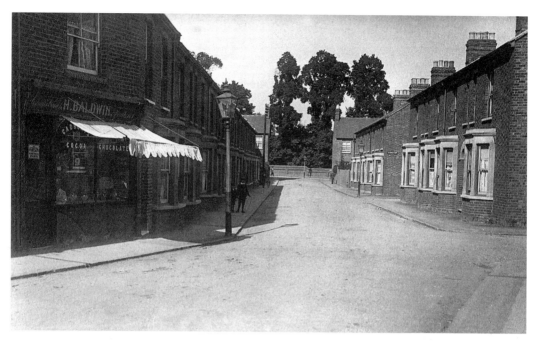

Queens Park, *c.* 1910. This view is from Princes Road looking towards the High Street. To the right is the entrance to Queens Park Road and further down is the Kings Road entrance. Baldwin's sweet shop on the left proved very popular with the schoolchildren of Queens Park School for many years. *(R.J. Johnson)*

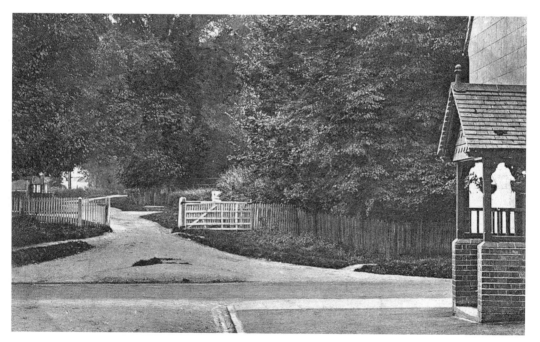

Turnfurlong viewed from the end of Highbridge Road, *c.* 1910. This was just a narrow lane leading to Turnfurlong Farm and eventually Bedgrove Farm. Behind the gate to the right are the grounds of Walton Grange. The porch in the foreground formed part of the Millwrights Arms pub. *(R.J. Johnson)*

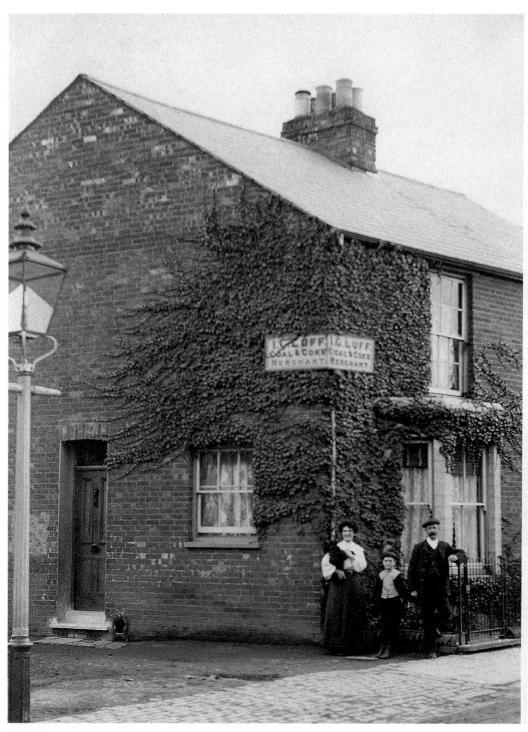

This charming photograph from about 1910 shows a house on the corner of Fleet Street and New Street. It was the home of the Luff family who, as is indicated by the sign on the building, were coal merchants. *(R.J. Johnson)*

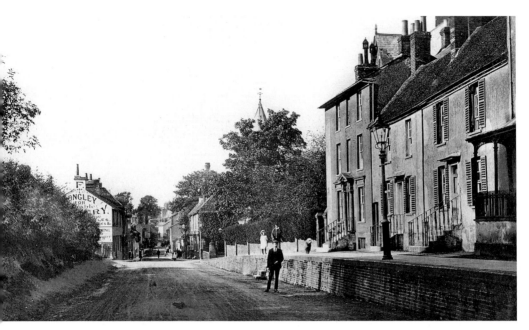

Walton Street, 1910. This view is looking towards town and shows the familiar row of buildings on the right which look remarkably unchanged today. Behind the large tree in the centre is Holy Trinity Church. The painted building on the left advertises Longley's drapers, which was in the High Street. *(R.J. Johnson)*

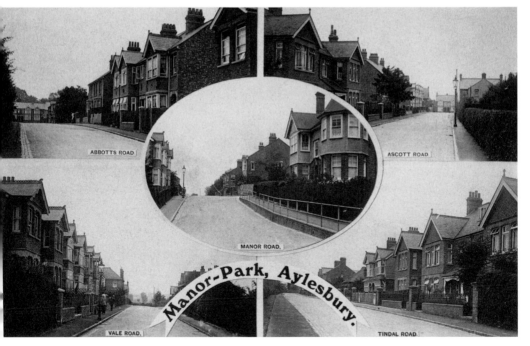

The Manor Park estate, *c.* 1910. These photographs were taken not long after the estate was largely completed. The houses on Vale Road would have had a clear view towards the north-west as there were no houses on the opposite side of the road at that time. *(K. Vaughan)*

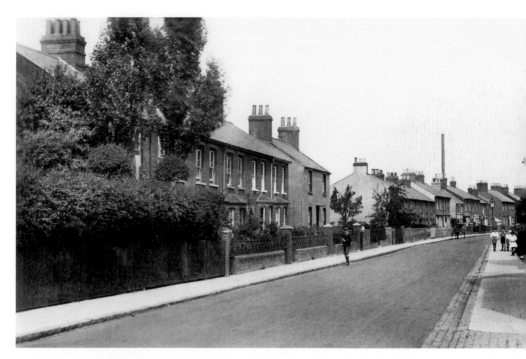

Looking down Northern Road, *c.* 1910. This road was among the first to be laid out in the late Victorian period as the town began to encroach on the surrounding farmland. The chimney in the distance shows the site of the Aylesbury Steam Laundry. *(K. Vaughan)*

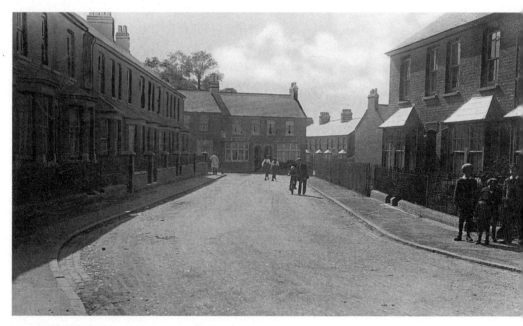

Looking down Princes Road on the Queens Park estate, *c.* 1910. Houses in Highbridge Road are seen facing us with Beaconsfield Road beyond. *(R.J. Johnson)*

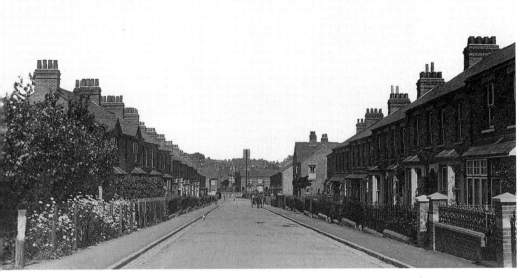

Highbridge Road looking towards town, *c.* 1910. As with Manor Park, these houses too were newly built and appear quite uniform with their neat brick walls and railings. *(R.J. Johnson)*

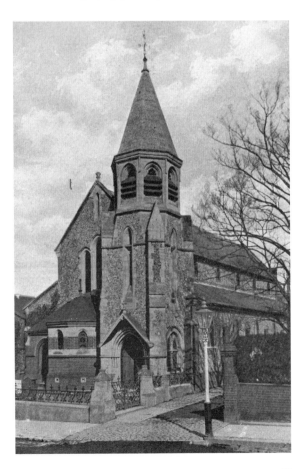

Holy Trinity Church on Walton Street, *c.* 1910. The church was built in 1845 and enlarged in 1886–7. To the right of the church is Croft Passage (now Croft Road). *(K. Vaughan)*

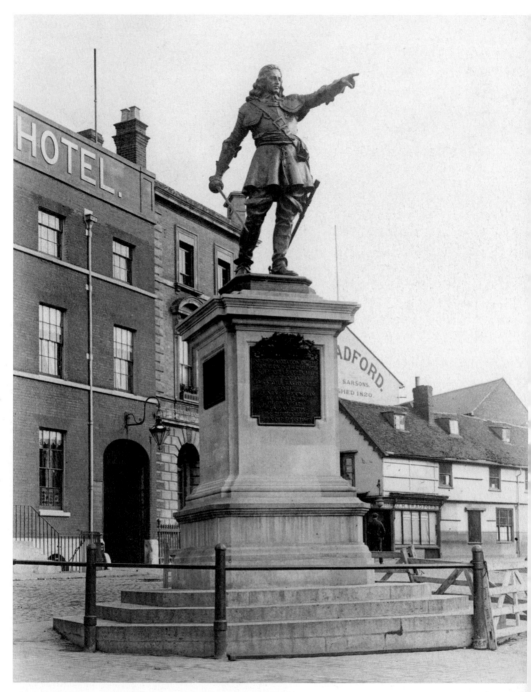

The statue of John Hampden in Market Square, 1912. The foundation stone was laid on 22 June 1911 which was the coronation day of King George V. The statue was sculpted by H.C. Fehr and was unveiled on 27 June 1912. Both the statue and bas-reliefs of 'The Battle of Chalgrove Field' and 'The Burial of John Hampden' were presented as a coronation gift to the county by James Griffin of Long Marston. The statue has recently been moved to a different site at the top of the High Street – only a few yards away from its original position. *(K. Vaughan)*

Walton Engine Works, 1912. The works were situated in Walton Road where Landon Court now stands. Run by William Morris, the works produced many different items such as drain covers and lamp-posts. Even today some of these things remain dotted around the town, in particular, drains with the Morris name stamped on them. *(K. Vaughan)*

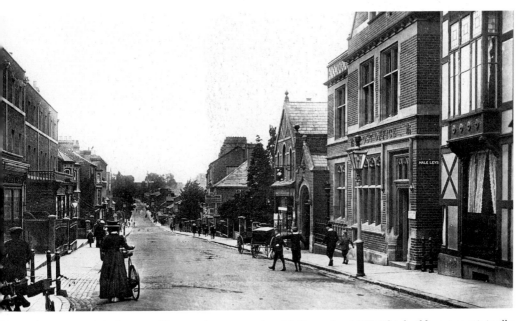

The High Street, 1914. The post office seen here opened on 25 November 1889. This building was originally home to the Telephone Exchange before it moved to newly built premises in New Street on 8 March 1957. In September 2007 the post office moved from the site it had occupied for 118 years. It is now located in W.H. Smith, to the rear of the shop. *(K. Vaughan)*

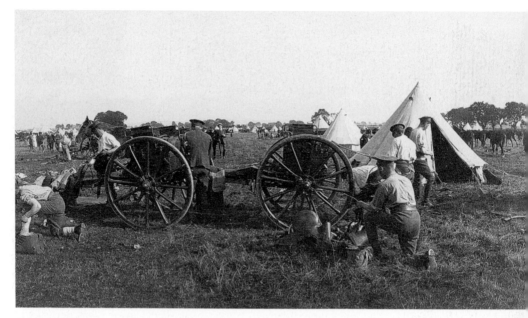

Army manoeuvres on the outskirts of Aylesbury around the time of the First World War. An old Aylesbury resident remembered seeing this kind of activity down Turnfurlong. For instance, there were goalpost-like structures dotted about the field with bags of straw hanging from them. This was so the men could practice running at them with their rifles and bayonets. *(R.J. Johnson)*

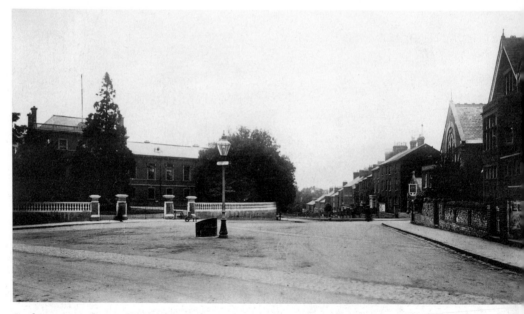

Looking towards Buckingham Road from the end of Buckingham Street, *c.* 1915. The Royal Buckinghamshire Hospital is on the left. The two buildings on the right are Melrose House, nearest, and the Primitive Methodist church which opened in 1882. The last service held there was in March 1951. Both buildings have since been demolished. *(R. Adams)*

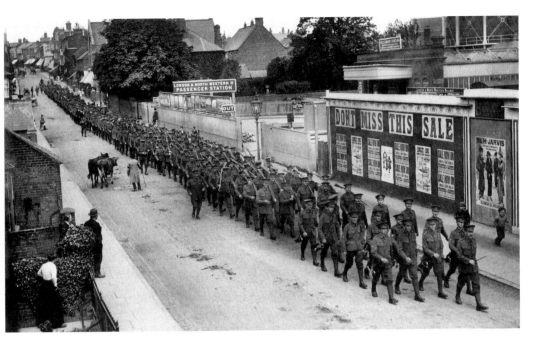

The First World War is well under way and we see here a great number of soldiers marching past the LNWR station in the High Street in the summer of 1915. One of the four men at the very front of the march was Frank Moore from High Wycombe. This view is from a postcard he sent home to his dad. Little did these men know what was ahead in this bloody conflict; in the coming years they would experience hell on earth. A great debt is owed to these brave soldiers. *(K. Vaughan)*

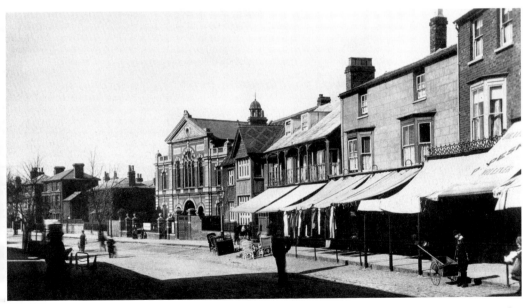

Buckingham Street, 1916. Instantly recognisable is the large Methodist chapel down the street. Just up the street towards us is a jumble of items for sale outside Jenns, the house furnishers. The next shop along is the draper's shop of Frank Madder. *(K. Vaughan)*

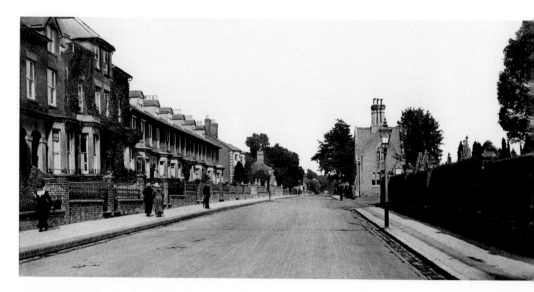

A very empty Tring Road, *c.* 1916. This view is looking out of town with the cemetery on the right. The huge trees in the distance show where the road carries on into open countryside. Some of the houses stretching down on the left were occupied by workers in the nearby printing factories and dairies. *(K. Vaughan)*

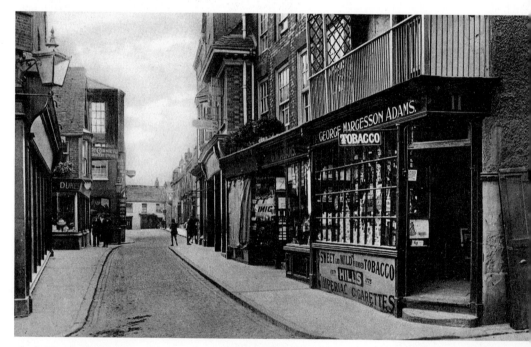

Market Street, 1918. This is the narrowest and shortest street in the town centre and is very ancient. Here we see George Margesson Adams' tobacconists which remained on that same site until fairly recently. The large building protruding on the left is M.T. Cocks, the wine merchant and grocer. Next to that there is a very old building that was Dukes' china shop. Today very few of these buildings remain and, amazingly, the street has escaped being widened. *(R. Adams)*

2

THE 1920s & 1930s

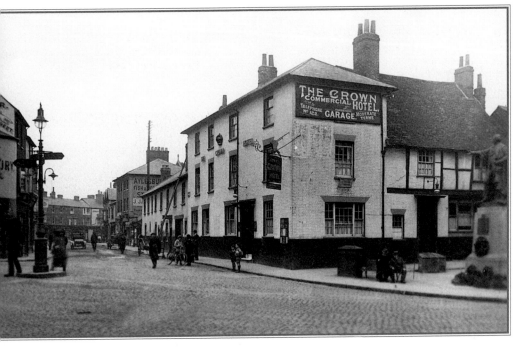

The Crown Hotel at the top of the High Street, 1920s. *(M. Sale)*

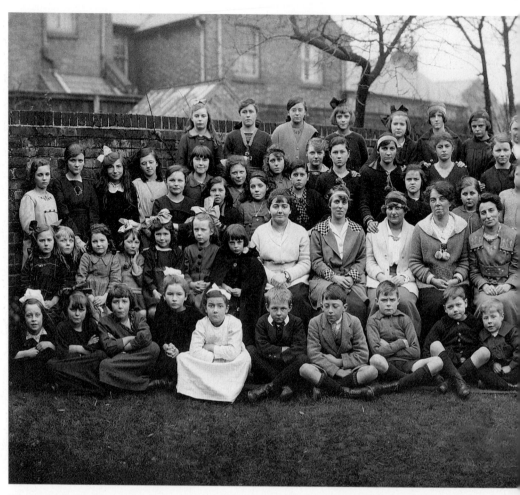

We open this chapter with a photograph of the teachers and pupils of Temple School in Buckingham Street February 1920. The school started in Temple Square in the late 1880s and was run by Miss Locke, who came from a well-known Aylesbury family. At the turn of the twentieth century it was taken over by Miss Amery and Miss Gleaves, and continued on that site for a few years until about 1910 when they moved to Putnam House in Buckingham Street. The house was used for boarders, while at the rear were classrooms.

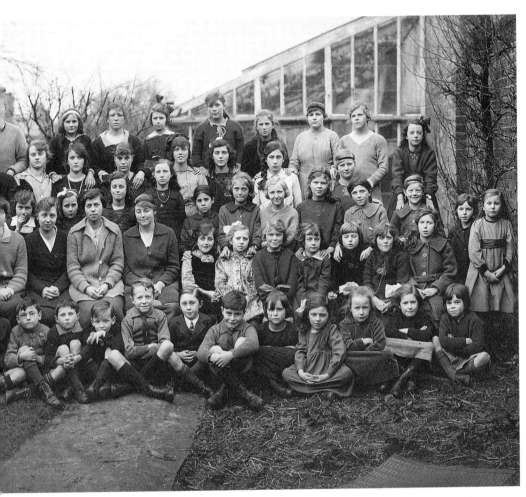

that backed on to New Street. This was where the Upper School was situated. In Church Street was Temple School's kindergarten. In about 1936 we find that Putnam House has become the home of the Mid-Bucks Shelter & Maternity Home, but the school was still there behind it. By 1940 the school had disappeared, both from Buckingham Street and Church Street. Putnam House itself was demolished in 1970. The site is now occupied by the large office block called Fairfax House. *(K. Vaughan)*

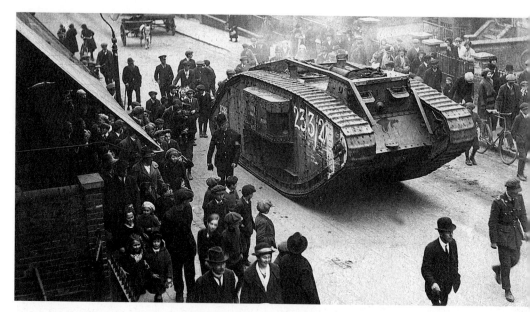

A 30-ton German tank in the High Street on 24 March 1920. It was captured during the First World War and given to the town by the National War Savings Committee. Its destination was Kingsbury and it remained there for nine years. In June 1929 there was an explosion when two men were using blow-torches to dismantle the tank. One of the workers was thrown 6 feet into the air and a distance of 20 yards. The other, who was on top of the tank, caught the full force of the blast and was thrown to the ground with his clothes alight. The blast was thought to have been caused by a concealed petrol tank deep inside the machine. It was reported that the explosion threw one of the workers' hammers into a garden in Kingsbury. A chisel was found in a neighbouring yard. (R. Adams)

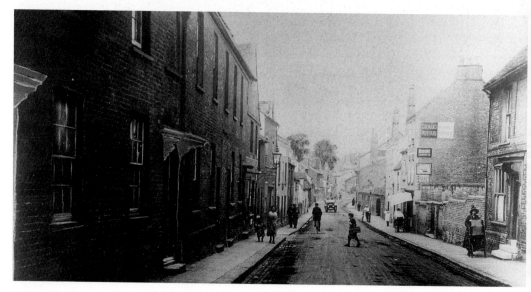

Walton Street, c. 1920. Behind the houses on the left were some of the poorer parts of town, namely Prospect Place and Garner's Row. They were demolished in about 1925. In the years following, all of the buildings on that side would also be demolished. All that remains of this view today are two buildings on the right – the one with the 'Colman's Mustard' advert and the small building next to it. (M. Sale)

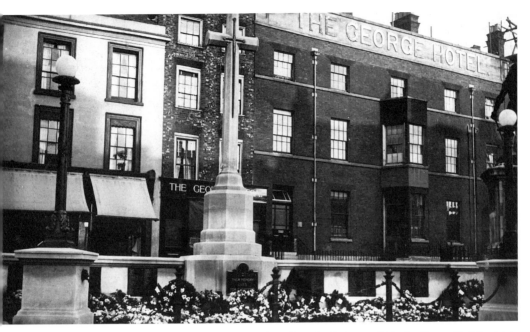

Market Square, 1921. The war memorial seen here had just been built. Beyond it is the George Hotel, which was closed in that year. Just visible on the far right is scaffolding surrounding Lloyd's Bank which was undergoing expansion at the time. *(K. Vaughan)*

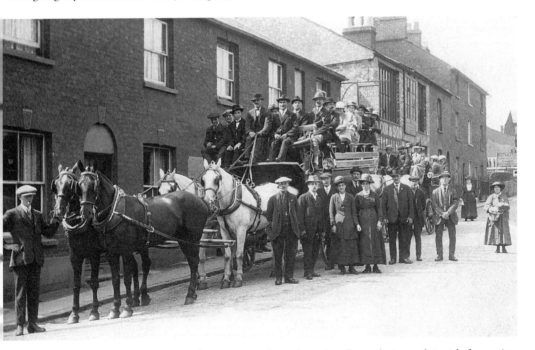

Station Street, *c.* 1921. Here we see a large group of people posing for a photograph just before going off on an outing. They are outside the original Prince of Wales pub, which was later rebuilt to a different design. Further up the street on the far right of the picture is the yard of builders Mayne & Son. *(R.J. Johnson)*

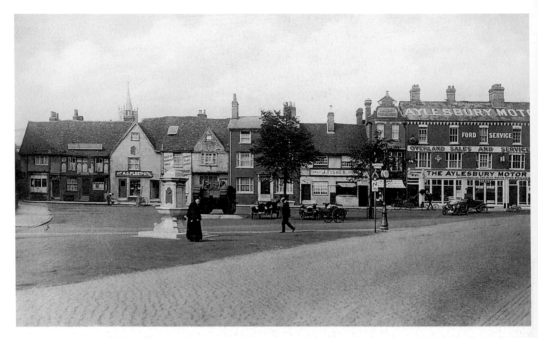

Kingsbury, 1921. The tank featured on page 40 is seen in its final resting place. The fountain in front of it was later moved to its present position in Vale Park. Behind it to the left is the shop of basketmaker Amos Charles Fleet. The Rockwood pub is to the left: at this time it was smaller than it is today. *(R.J. Johnson)*

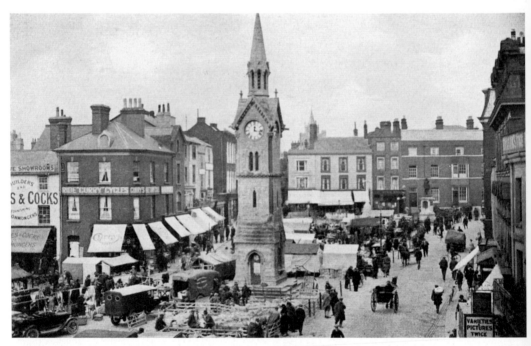

Market Square, *c.* 1922. At the top of the square the large sign of the George Hotel has been removed because of its closure. The building was taken over by the Territorial Association in 1921, and it was demolished in 1935 when Montague Burton built their menswear shop on the site. *(K. Vaughan)*

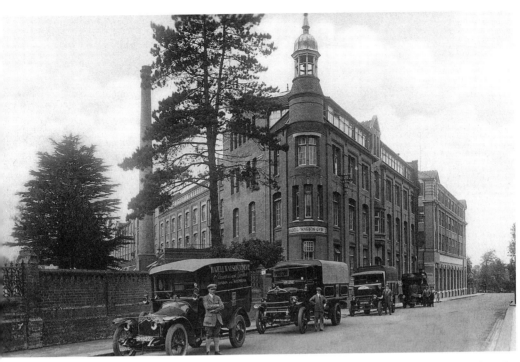

The printing works of Hazell, Watson & Viney on the Tring Road, early 1920s. The firm closed in the mid-1990s and today nothing is left of these huge factory buildings that occupied both sides of the road. *(R.J. Johnson)*

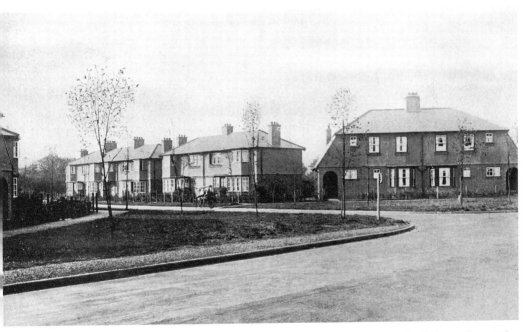

Walton Way, early 1920s. Taken from Tring Road, this shows the houses that were built for workers at the nearby factory of Hazell, Watson & Viney. *(R.J. Johnson)*

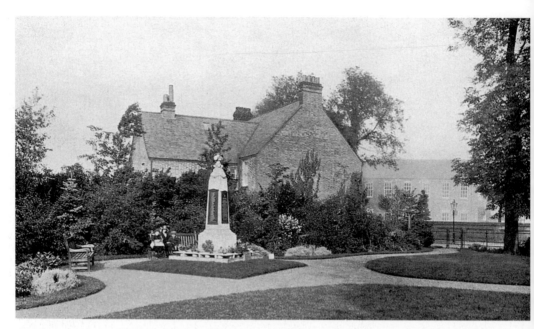

The war memorial of Hazell, Watson & Viney on the corner of the High Street and Walton Road, early 1920s. The memorial was erected in memory of sixty-five employees who lost their lives during the First World War. It was unveiled by the Marquess of Lincolnshire on 20 November 1920. A tablet with seventeen names was added after the Second World War. Sadly this memorial no longer exists, as a roundabout was put here in the late 1960s. *(R.J. Johnson)*

Hartwell Road, *c.* 1925. This is a view of the road just before it turns at the Bugle Horn pub, and what a peaceful scene this is. It is quite different today – a very busy main road into Aylesbury. *(R.J. Johnson)*

Members of the Dramatic Society of Hazell, Watson & Viney parading in Market Square, mid-1920s. *(R.J. Johnson)*

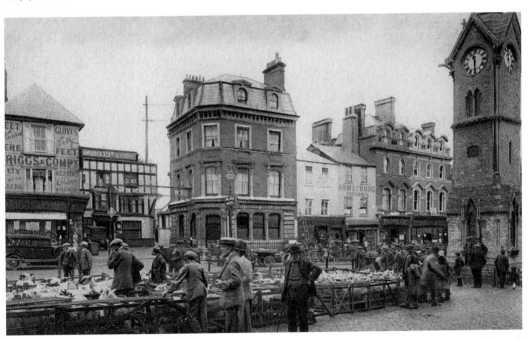

Market Square, late 1920s. The Bull's Head Hotel in the left background had just recently been refronted by its proprietor G. Gargini. The large Victorian building in the centre is the Westminster Bank. Two doors down from there is Armstrong's stationers – one of quite a few places in the town where one could buy picture postcards of Aylesbury and the surrounding area. *(K. Vaughan)*

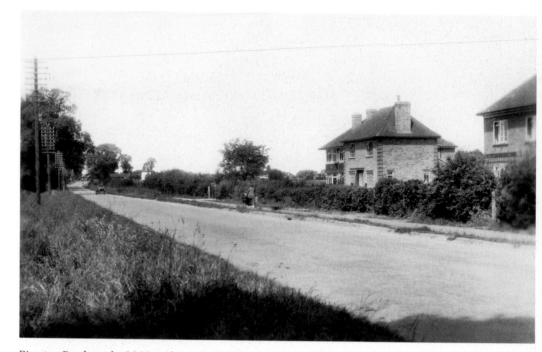

Bicester Road, early 1930s. This remarkable view was taken opposite the Stonehaven Road turning and looks out of town. The houses fronting the road had only recently been built and at that time were surrounded by countryside. Since then the Quarrendon housing estate has been built behind them and opposite are retail units and car showrooms. *(K. Vaughan)*

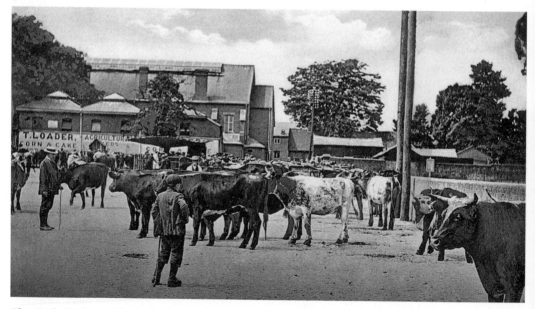

The Cattle Market, *c.* 1930. The large building at the back is the Town Hall. Adjoining it was the premises of T. Loader, corn merchant. *(R.J. Johnson)*

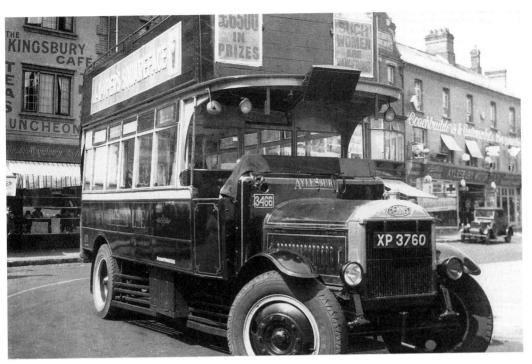

A bus in Kingsbury, *c.* 1930. The bus station was established here in 1929. This photograph was taken some time before the shelter was built in 1938. The Kingsbury Café seen on the left behind the bus was an ideal place to pass time while waiting for a bus. *(D. Bailey)*

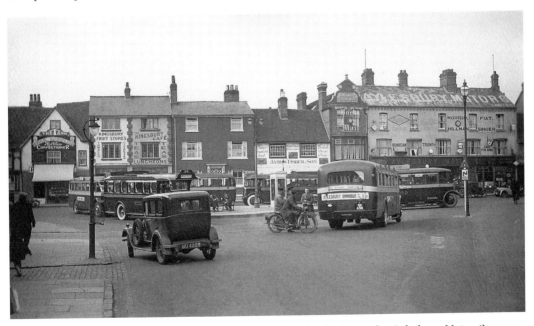

Another view of Kingsbury at about the same time. This clearly shows the Aylesbury Motor Company on the right advertising the many different makes of cars that they sold – Sunbeam, Triumph, Morris, Hillman, Fiat, Singer, Riley and Austin. Quite a selection! *(R.J. Johnson)*

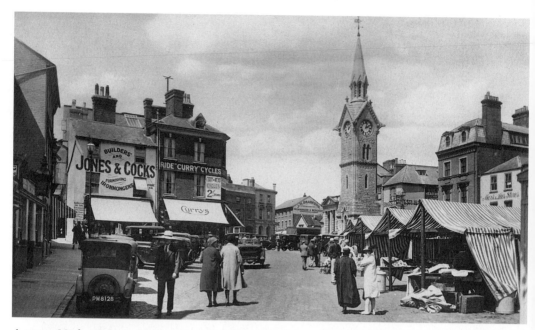

A sunny Market Square, 1933. Up on the left past Jones & Cocks is the Old Beams restaurant, which is seen again later on in this chapter. Just visible at the top of the square in Kingsbury is Bradford's, the ironmongers. Their premises were demolished in 1934 to make the turning easier for vehicles coming out of Buckingham Street. Brooke House now stands on the site. *(K. Vaughan)*

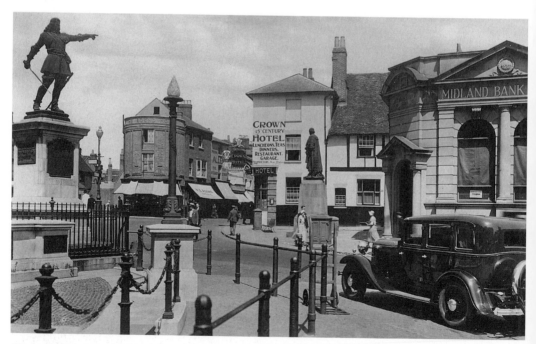

Market Square, 1933. This shows the Crown Hotel after it had been refurbished in the same year. It is a great shame that this turned out to be in vain, as it was demolished in 1937 to have shops built on its site. *(K. Vaughan)*

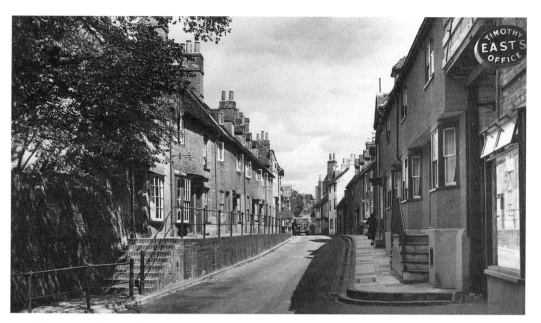

Castle Street, mid-1930s. This street shares a characteristic with Walton Road and Walton Street: they have all had their surfaces lowered to make travelling easier for horses coming into town with carts. At the end of the street the pub sign for the Black Horse can be seen. This pub closed in about 1938. *(M. Sale)*

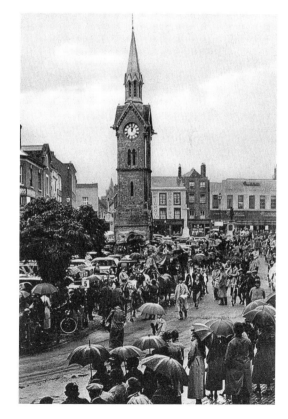

This procession through Market Square was for the Royal Bucks Hospital Extension Appeal Week and shows an old-time stagecoach on its way through. The appeal was held in July 1935 and 1936, and other events included a swimming gala at the Vale Pool, a masked ball at the Town Hall and decorated vehicles that proceeded through the town. *(R.J. Johnson)*

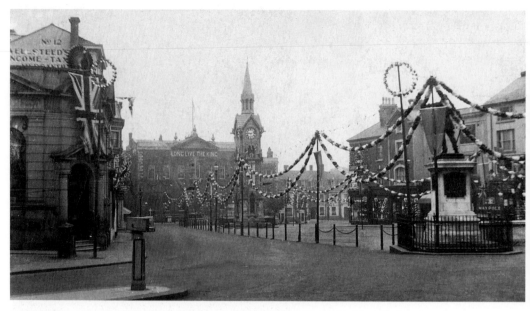

Market Square decorated for the coronation of King George VI, 1937. *(D. Bailey)*

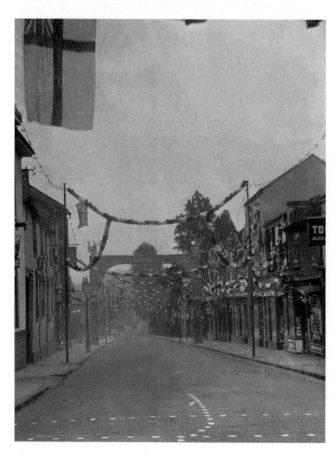

This is how Walton Street looked during the coronation. These two photographs must have been taken on a Sunday judging by how deserted the town looks. *(D. Bailey)*

Old Beams restaurant, Market Square, 1938. This was one of the oldest buildings in the square and was tucked away behind Jones & Cocks, ironmongers. *(R.J. Johnson)*

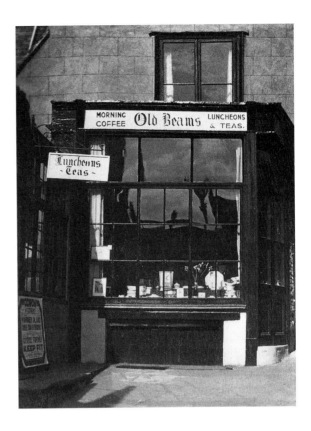

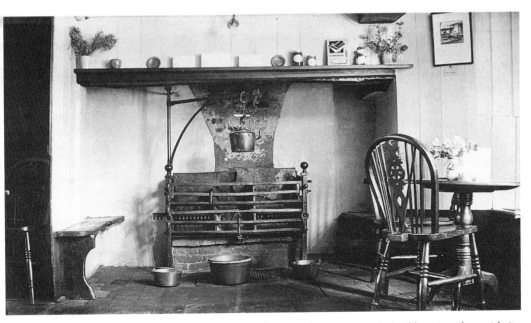

A view of the interior of the restaurant, showing how quaint it was. This building together with its neighbours was demolished in 1964 to make way for Friars Square. *(R.J. Johnson)*

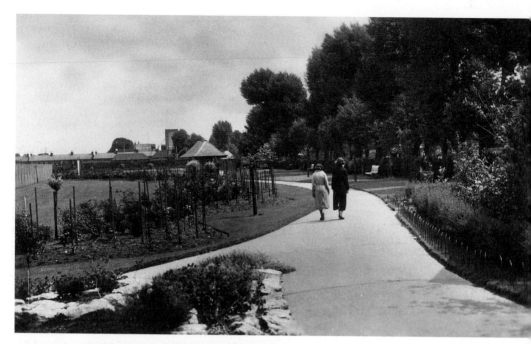

Vale Park, 1938. Formerly a cricket ground and the meeting place of the Vale of Aylesbury Cycling and Athletic Club, it was bought by the Corporation in 1929. Tennis courts were opened in the same year and on 1 July 1937 the park itself was opened by Alderman A.T. Adkins, who was the mayor at that time. *(R. Adams)*

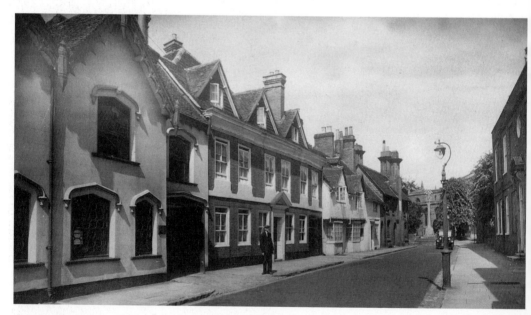

Church Street, 1939. This view shows the very fine frontage of the Chantry on the immediate left, which is a sixteenth-century building altered in the 1840s. In the 1860s it was the home of Robert Gibbs, who wrote his *History of Aylesbury*. This was published in 1885 and is still a very interesting read today. *(K. Vaughan)*

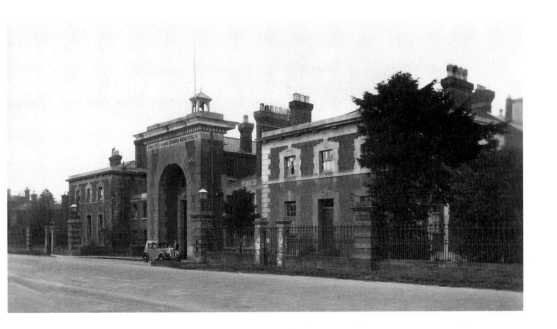

The prison on Bierton Road, late 1930s. The building opened in 1847 having moved from behind the County Hall in Market Square. Public executions were occasionally carried out here: over the main archway was a drop mechanism for hangings. On 24 March 1854 the first execution was of a man called Moses Hatto, who had committed murder at Burnham Abbey. The last public execution held here was in 1864. *(K. Vaughan)*

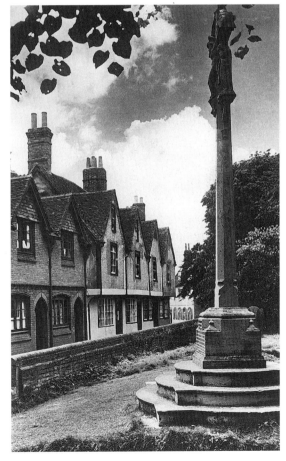

Parsons Fee, late 1930s. This narrow lane connects Castle Street with Church Street. In the foreground is the memorial commemorating the First World War. It was unveiled by the Marquess of Lincolnshire on 20 March 1925. Being in a conservation area, Parsons Fee still retains its character. *(K. Vaughan)*

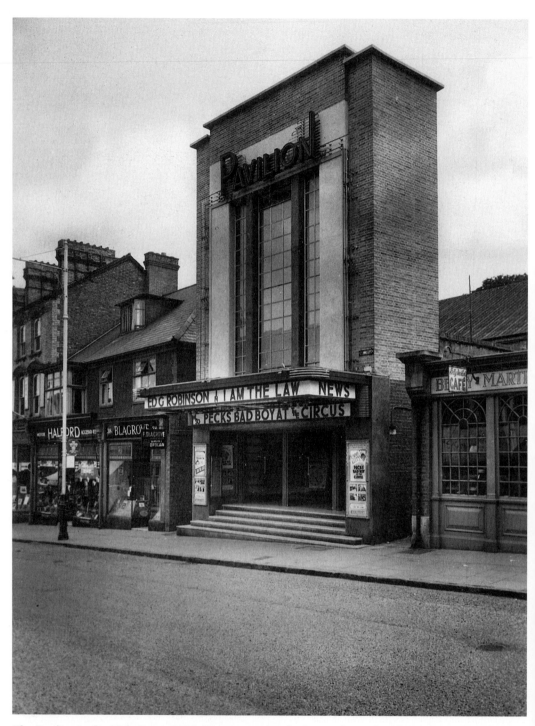

The Pavilion in the High Street, 1939. The cinema was built on a former builder's yard and was opened on 2 March 1925. It was enlarged in 1936 and remained the Pavilion up until June 1947, when it was renamed as the Granada. It is no longer a cinema and has for some years been the Gala bingo hall. (R. Adams)

3

THROUGH THE WAR YEARS
& ON TO THE 1950s

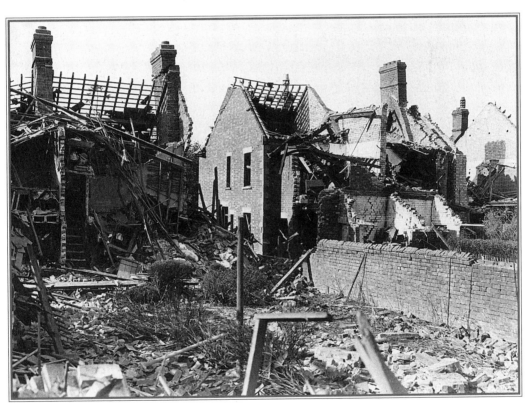

Victorian houses damaged by the Walton parachute mine explosion, 1940. *(E. Viney)*

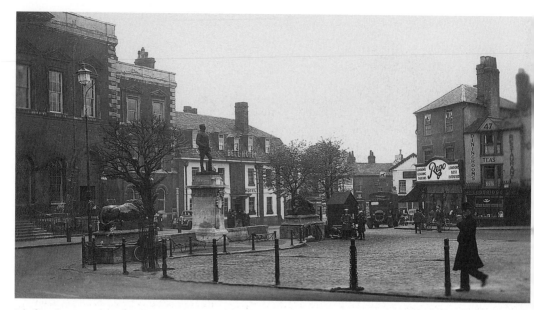

Market Square, 1940. In the distance is the entrance to Great Western Street, with the Greyhound pub standing at the bottom of Silver Street. *(R.J. Johnson)*

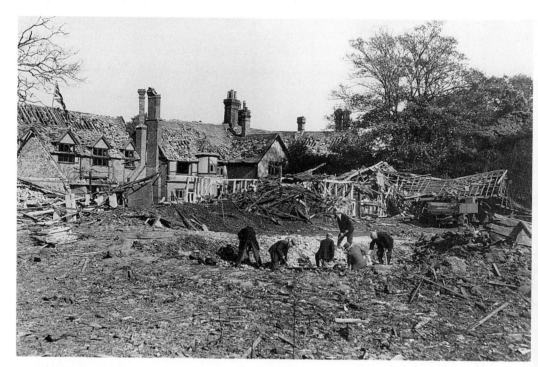

On 25 September 1940 a parachute mine exploded in Walton Road behind Walton Grange. People nearby saw something float down from the enemy aircraft. When it went off, the explosion was beyond belief. In the photograph we see workers sifting through the debris in the crater which was left by the blast. The building behind is Walton Grange: the damage to this fifteenth-century building was so severe that it was demolished shortly afterwards. Also of note is the Union flag stuck on its roof by a local as a sign of defiance. *(E. Viney)*

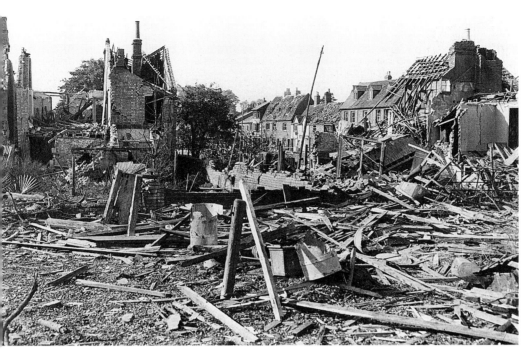

Other buildings which suffered badly from the explosion were those fronting Walton Pond. These were solidly built Victorian houses. Mr J. Johnson, who lived at 20 Walton Road, was killed when the parachute mine went off. It was rumoured that he was looking for his cat at the time. In the distance are houses on Walton Road which still exist today. Being further away, they suffered only superficial damage such as dislodged roof tiles and blown-out windows. *(E. Viney)*

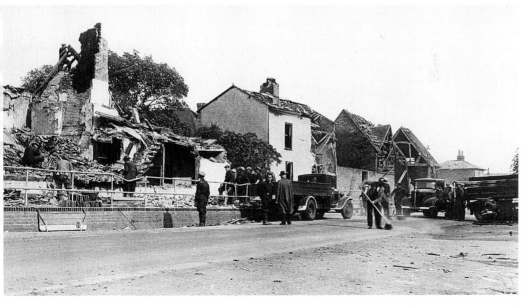

These cottages on the opposite side of the road to Walton Grange were also severely damaged. They were of a similar age to the Grange. Being timber-framed they must have just shaken to bits. *(E. Viney)*

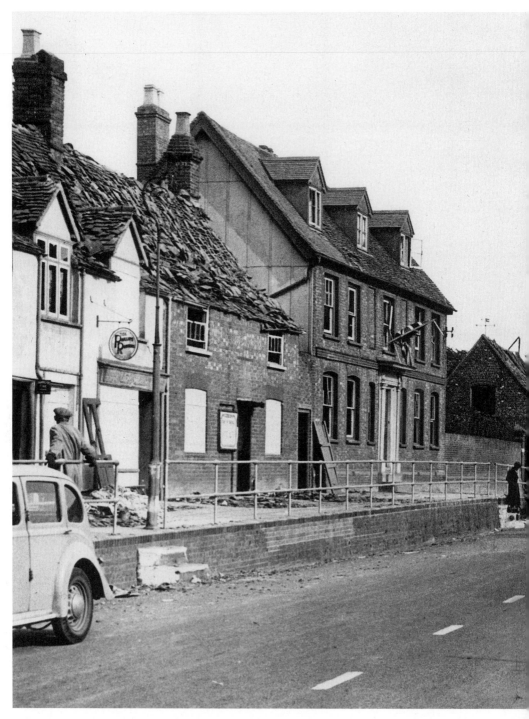

A final look at the Walton parachute mine damage. Here we see a view down Walton Road taken from near its junction with Wendover Road. This really does show how much mess was made by the explosion – the force of the blast must have been incredible. Even a few buildings in town suffered with blown-out windows. It's a wonder that the houses on the left weren't more severely damaged. *(E. Viney)*

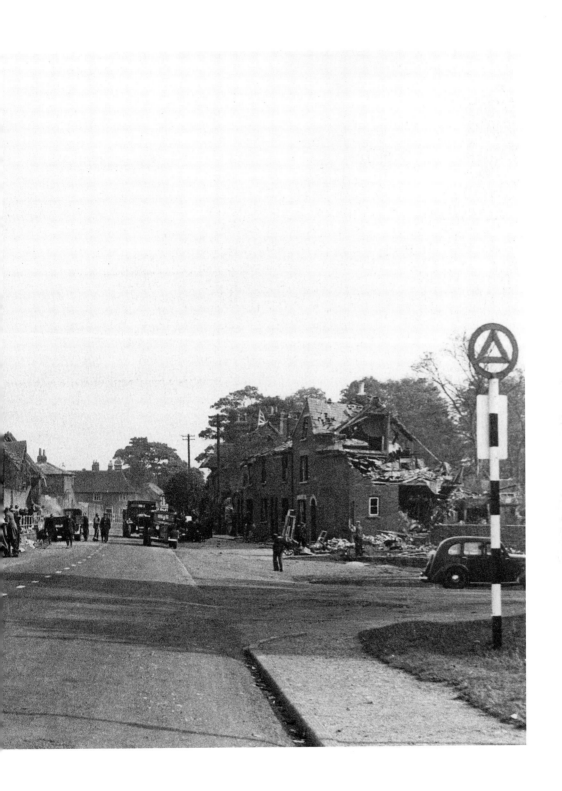

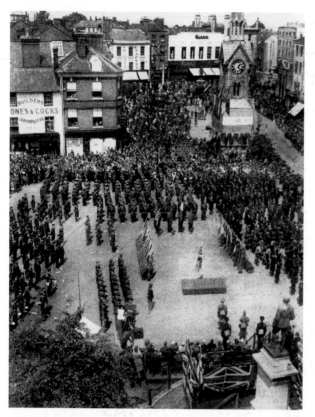

Market Square during the celebrations of United Nations Day on 14 June 1942. The American-born mayor, Mrs Olive Paterson, read a government message, while American troops (on the left) and units from other Allied forces paraded. *(K.Vaughan)*

A busy bus station in Kingsbury, 1944. In the centre is the bus shelter which was built in 1938. On close inspection, there are some American soldiers standing among the crowds of people, plus a few of our own too. The bus station moved to its present location in Great Western Street in the late 1960s and Kingsbury has recently had a makeover making it a largely pedestrian area with a water feature as its main focal point. *(K. Vaughan)*

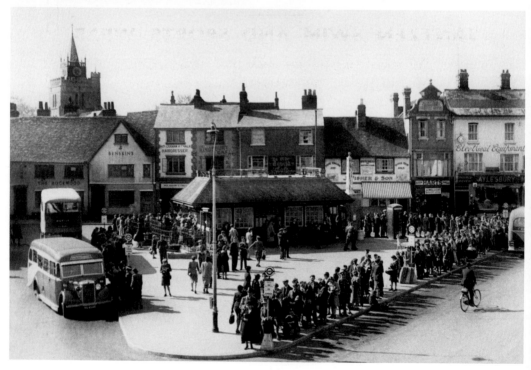

1947

MEN'S WEAR

*As the general supply position improves, we hope to be able to
meet many more of the numerous enquiries we receive daily for*

SIMPSON CLOTHES
DAKS AND PADAK RAINCOATS

BURBERRYS

CHRISTY'S HATS

VANTELLA AND MARTUS SHIRTS

VIYELLA SHIRTS AND PYJAMAS

JANTZEN SWIM AND SPORTS WEAR

*For which we are the accredited Local Agents.
Also to extend our personal Tailoring Service*

SPRAGG & SON

The Man's Shop

10 HIGH STREET, AYLESBURY

TELEPHONE——————367——————AYLESBURY

An advert for Spragg's in the High Street, 1947. *(K. Vaughan)*

Market Square, *c.* 1948. On the right is the clothing store of William McIlroy, which was rebuilt in 1954 when Courts moved in. In the centre of the square on non-market days the space was used as a car park. This is before the days of the car parks we know today. *(M. Sale)*

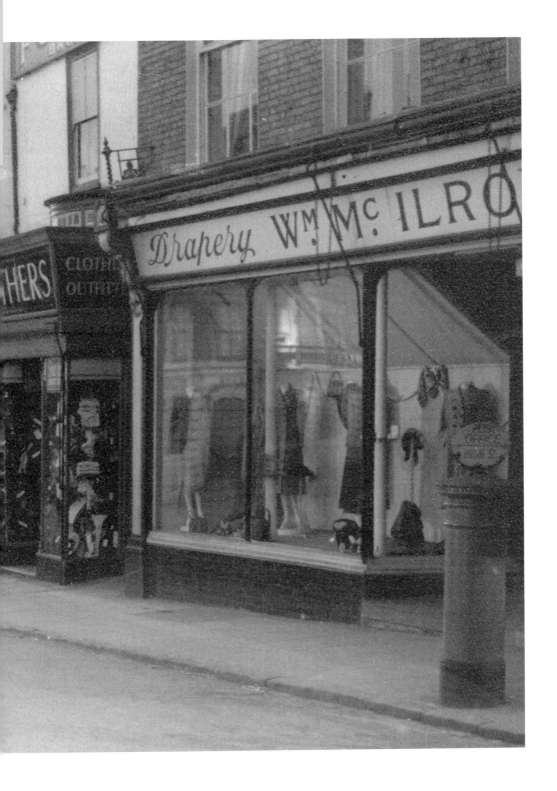

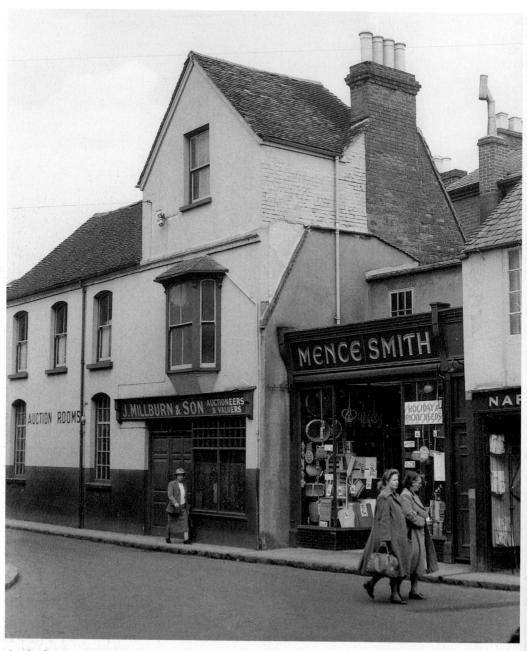

Cambridge Street, April 1950. Next to the hardware shop of Mence Smith is Millburn's Auction Rooms. The building was erected in 1881 and the upper floor was leased from 1907 to Valentine Jarvis, draper, in the High Street. After the auction rooms closed in 1950 the whole building was occupied by Jarvis until 1981, when it was demolished. *(J. Millburn)*

Eagles Road, early 1950s. The road at that time was more like a dirt track. On the left behind the fence is the sports ground of Hazell, Watson & Viney. *(R.J. Johnson)*

The Oddfellows Arms on a wet day in the early 1950s. The man on the left is a postman on his way back to the depot at Upper Hundreds, which is just round the corner on the left. *(R.J. Johnson)*

A display in the shop window of Sale Brothers, grocers in Buckingham Street, in the early 1950s. *(M. Sale*

Looking up Park Street, early 1950s. At the very top of the street are buildings fronting Cambridge Street. On the right are the signal-box and gates at the level crossing. This was part of the LNWR line which went from Aylesbury to Cheddington and had its station in the High Street. Photographs of the station may be seen later in this book. *(R.J. Johnson)*

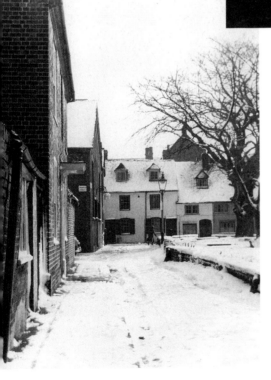

St Mary's Square after a good fall of snow, early 1950s. Just to the left of the white cottages is the Evangelist Hall, which was built in 1878. It was demolished and rebuilt in the 1960s. *(R.J. Johnson)*

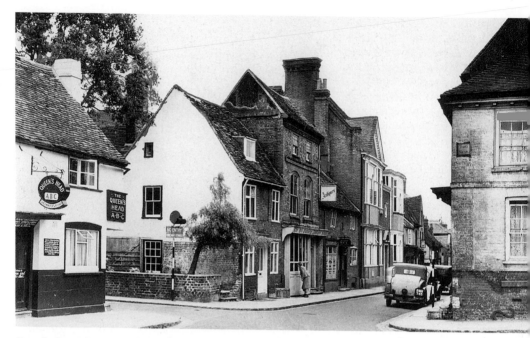

Temple Street from Temple Square, *c.* 1954. This is a part of town that hasn't altered much over the years. The Queen's Head on the left is still one of Aylesbury's more traditional pubs. *(M. Sale)*

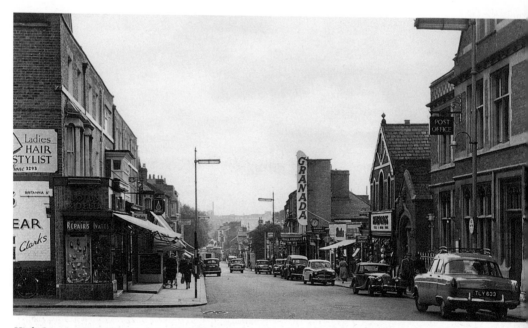

High Street, 1955. This is viewed from the entrance to Britannia Street, which is on the left. Earlier in this book we saw a photograph of the Pavilion cinema. Here we see it renamed the Granada. On the left is one of Ivatt's shoe shops, the other being in Kingsbury. *(M. Sale)*

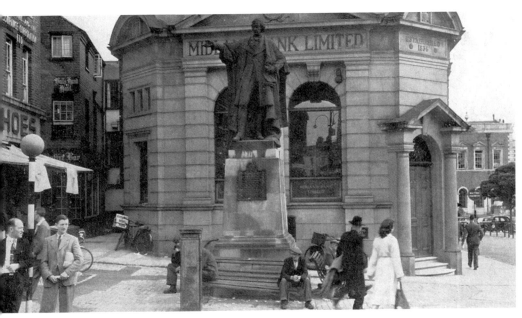

The Benjamin Disraeli statue in Market Square, mid-1950s. To the left is the side entrance to the Bull's Head Hotel. This passage is one of the oldest in the town today; however, the hotel itself has since gone. (*R.J. Johnson*)

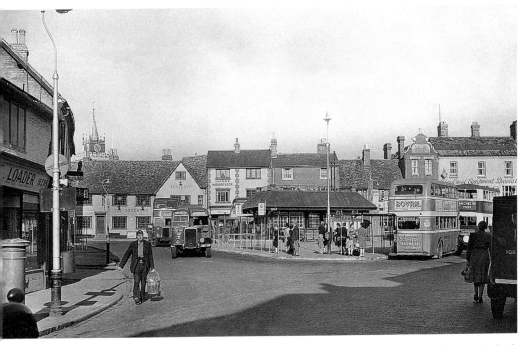

A busy bus station in Kingsbury, mid-1950s. On the left is Loader's, the corn and seed merchants, who had their stores at the rear of the Town Hall in Market Square. (*R.J. Johnson*)

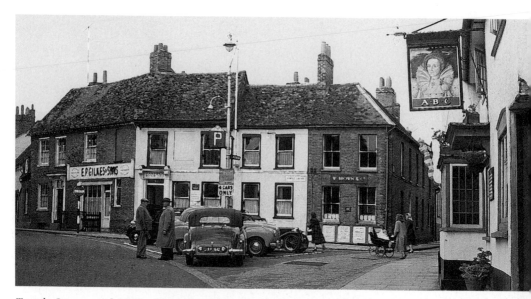

Temple Square, mid-1950s. This view shows the premises of builders Gilkes & Sons at the top of Castle Street. The pub sign on the right is that of the Queen's Head. *(R.J. Johnson)*

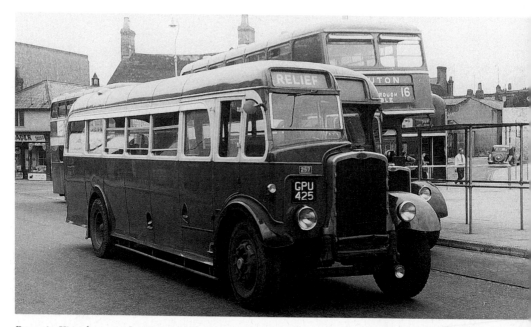

Buses in Kingsbury, mid-1950s. In the distance on the right we can see buildings in George Street. On the corner for some years was a rose garden that occupied the site of a demolished building until about 1959, when Kingsbury House was built there. Just visible is the row of cottages that used to front George Street. They were to the left of the entrance to the King's Head and were demolished shortly after this photograph was taken. *(D. Bailey)*

Prebendal Avenue, *c.* 1957. The photograph was taken at its junction with Hampden Road and looks towards Chestnut Crescent at the very end. Note the size of the grass verges – they have since been reduced to make the road wider for traffic. The Southcourt estate was started in 1920 and people were moved there from the slum areas of the town that were being demolished at the time. Prospect Place, Upper Hundreds and Whitehall Row were some of the areas that were cleared. *(K. Vaughan)*

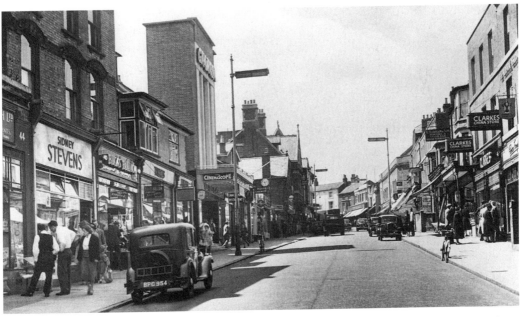

High Street, 1958. On the left is the tall frontage of the Granada cinema. Opposite there is Clarke's china shop with the clothes shop of George Tough next door. *(M. Sale)*

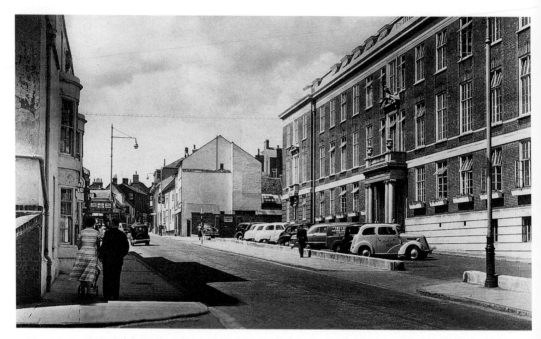

Walton Street looking towards town, 1958. The original County Offices are seen on the right. Facing them in the foreground is the Old House, a large building that disappeared for the construction of the new County Offices and library. Next door to it up the street was Walton Cottage, which also disappeared in the redevelopment. *(M. Sale)*

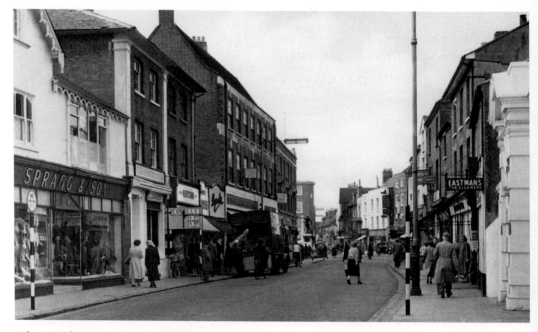

A busy High Street, 1958. On the left are the premises of drapers Spragg & Son. The large building further down is Crown Buildings, which takes its name from the Crown Hotel that was there before. Immediately on the right is the National Provincial Bank. *(M. Sale)*

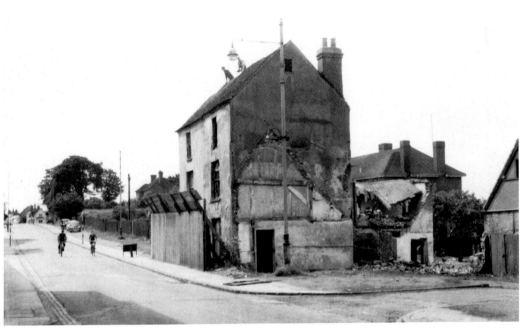

Walton Street, 1959. Here we see Osterfield's butcher shop and the adjacent building being demolished to allow for road widening. This pair of old buildings were the last to go on that side of the road. Mr Osterfield held out for as long as he could to try to stop the council taking his shop down but of course, the council won. At the top of the road the Horse & Jockey pub (now the Aristocrat) can be seen. *(K. Vaughan)*

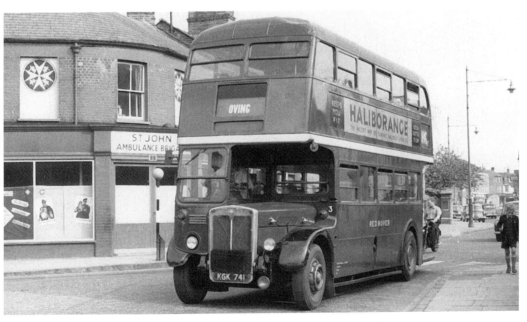

A bus going through the very narrow junction at the top of Buckingham Street, 1959. As more and more traffic went through town, this junction was one of the first to be altered: a pub called the Plough was demolished to allow road widening to take place. The St John Ambulance depot seen here later moved to a new site in Buckingham Road near the junction with Dunsham Lane. *(D. Bailey)*

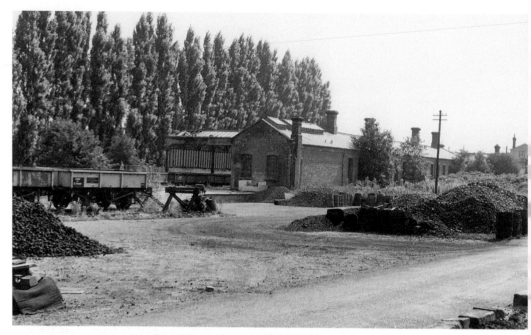

High Street station, *c.* 1959. This photograph is taken from the sidings of coal merchants William Hawkins. The station itself was closed to passengers on 31 January 1953 and was demolished in 1960. The track remained for a couple of years until it was taken up. The row of tall trees ran along by Lovers Walk next to Vale Park. The whole station site has since been replaced by a road called Vale Park Drive. *(M. Sale)*

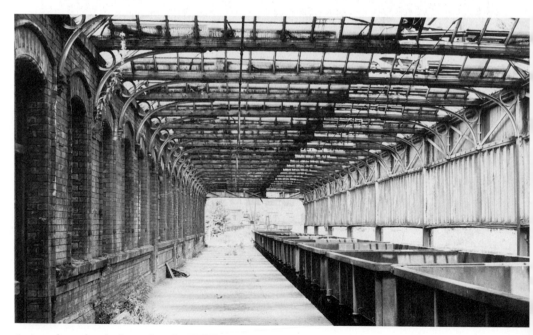

A view along the platform of High Street station, *c.* 1959. The station appears to be in a derelict state after having been closed for a few years. However, we can still see the fine cast iron work of the canopy above. When the station closed in 1953 the line was used for transporting goods. *(D. Bailey)*

4

THE 1960s & 1970s

Walton Street, 1960. *(M. Sale)*

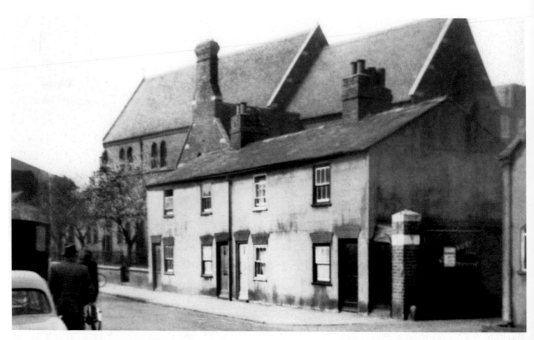

Cambridge Street, 1960. There was a time when Aylesbury was full of little cottages like the ones shown here but over the years they vanished. These particular ones were demolished shortly after this photograph was taken as they were deemed to be 'unfit for human habitation'. Behind them is another building that suffered the same fate as the cottages – St John's Church. It was taken down in 1970 and the area was used as a car park. *(K. Vaughan)*

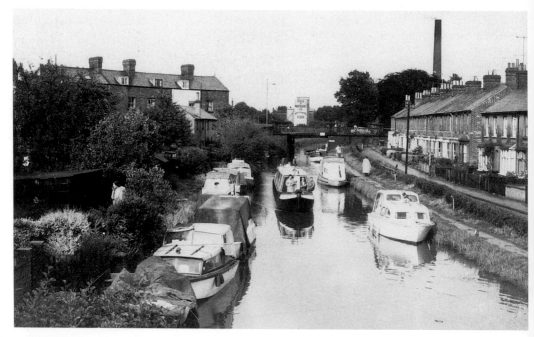

A view of the canal from the footbridge at Highbridge Walk, 1962. Straight ahead is the flour mill of Hills & Partridge, while to the right of that is the chimney of the Nestlé factory. *(M. Sale)*

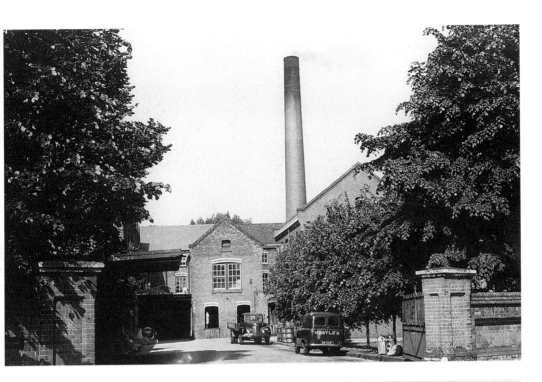

One of Nestlé's yards from the High Street, 1962. This photograph was taken before much of the old factory was demolished and a new block was constructed in its place. Now, sadly, the whole factory has gone and has been replaced by an apartment complex. However, the original factory clock that stood on the roof of the old building was saved and incorporated into the new one. *(M. Sale)*

Deep snow during the long cold winter of 1962/3. This was taken from the garden of my grandparents' house at 157 Buckingham Road, and is typical of the scene all over the town at that time. The canal was frozen over for months and plenty of garden vegetables were ruined. *(K. Vaughan)*

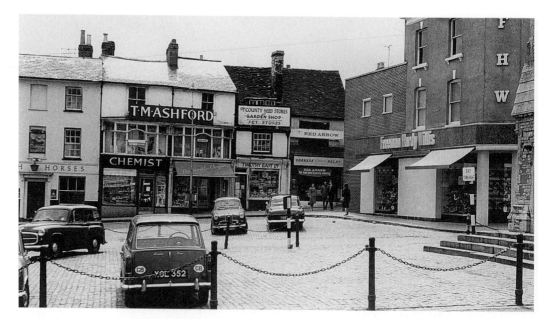

Market Square, 1963. To the right the Clock Tower can just be seen. Behind it is the shoe shop of Freeman, Hardy & Willis. The buildings facing us on the left disappeared in the following year to make way for Friars Square shopping centre. *(M. Sale)*

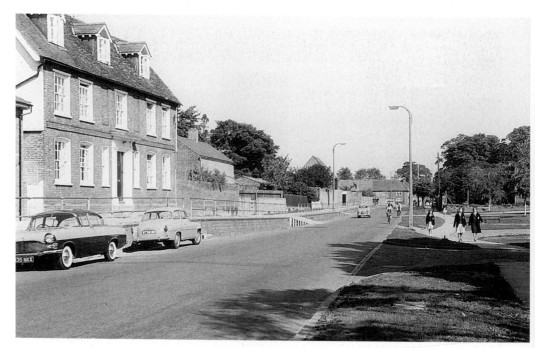

Walton Road, 1963. This view is from the Wendover Road end and presents a rather tranquil scene compared to twenty-three years previously when the parachute mine went off nearby. Walton Road still looks much the same today, although the terracing stops at the end of the large house up on the left where a small road called William Harding Close was put in. *(M. Sale)*

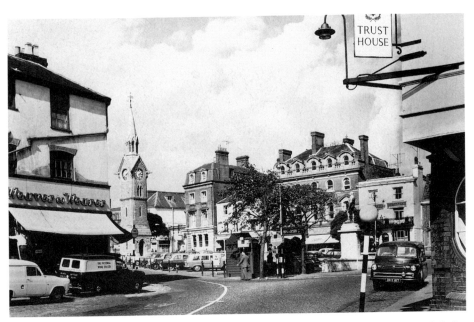

Market Square, 1963. This is from the entrance of Walton Street and shows on the left the clothes shop of Weaver to Wearer, a building that in a year would be levelled to make way for Friars Square. The building on the immediate right with the Trust House sign is the Bell Hotel. *(K. Vaughan)*

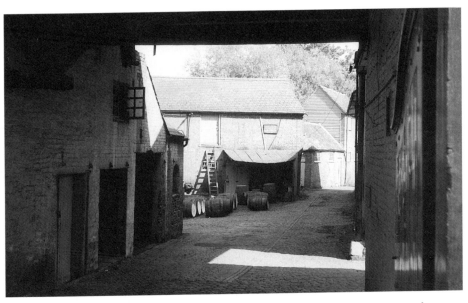

The yard of Walton Brewery, 1963. Although it was known by this name, it was taken over by the Aylesbury Brewery Company in 1895. This interesting and old group of buildings was all demolished in 1965 when the brewery modernised their business. A large unit was built at the rear while at the front, an office block called Planar House was built. This was demolished in about 1993 and has since been replaced by Old Brewery Close. The brewery itself is but a distant memory. *(M. Sale)*

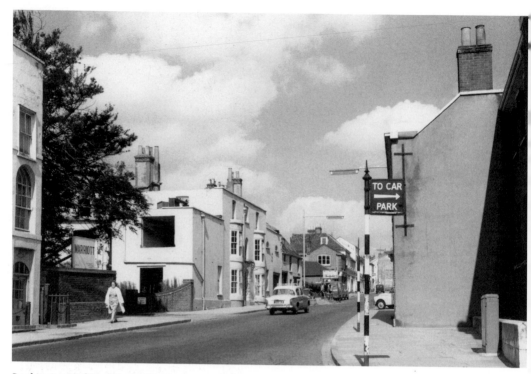

Looking up Walton Street at its junction with Exchange Street, 1963. This was taken during the first stages of demolition of Walton Cottage, which is the large white building in the centre. On its site the new library and County Offices were built. *(M. Sale)*

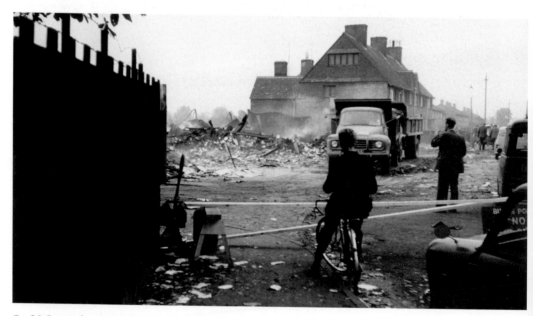

On 29 September 1963 there was an almighty blaze at the paper warehouses of printers Hazell, Watson & Viney. The scene shown here is of Victoria Street and shows how close the flames would have been to these houses. *(M. Sale)*

A detective carrying a box labelled 'fingerprints' into Buckinghamshire police headquarters on 19 August 1963. This was evidence gathered at Leatherslade Farm near Oakley during the aftermath of the Great Train Robbery a few days earlier. It is well known that while the robbers hid out at the farm, they played Monopoly and unwittingly left a wealth of clues behind, giving the police exactly what they needed to identify who was behind it all. In the months and years following this crime of the century, most of the robbers were captured and some received sentences of up to 30 years in prison. *(K. Vaughan)*

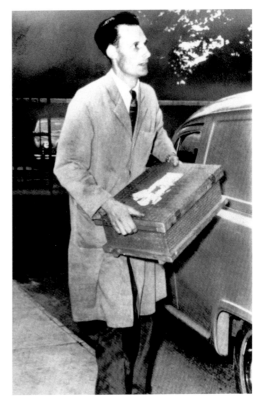

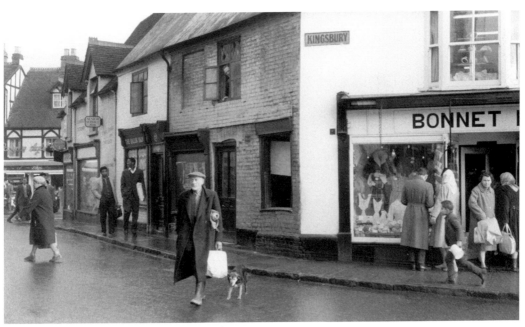

Kingsbury where it turns into Buckingham Street, 1963. These buildings on the corner were demolished a little while later. The ladies' outfitters Bonnet Box appears to be having a busy day – maybe they had a rush on headscarves! *(M. Sale)*

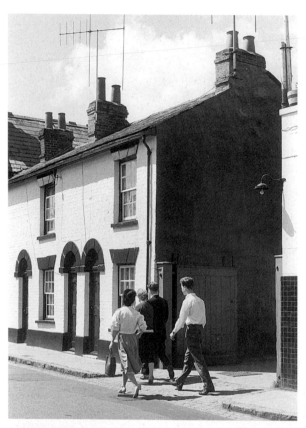

Houses in Exchange Street, 1963. Where the people are crossing was the yard of the Chandos Hotel, which stood at the end of the street. That building together with these houses disappeared in 1981, to be replaced by a large office block called 66 The Exchange. *(M. Sale)*

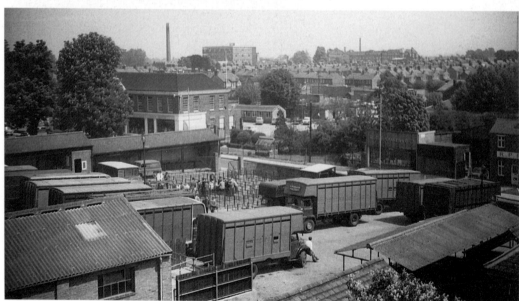

This is a good view of the town in 1963, from the rear of the old County Offices on Walton Street. The cattle market and Exchange Street are below. The large square building on the horizon is the newly built extension to the Nestlé factory on the High Street. *(R. Adams)*

Market Square, 1964. This shows the row of buildings that was soon to be demolished for the construction of Friars Square. Old Beams restaurant is straight ahead. At the right of the building is a passage that led to the rear of the Dark Lantern pub. *(M. Sale)*

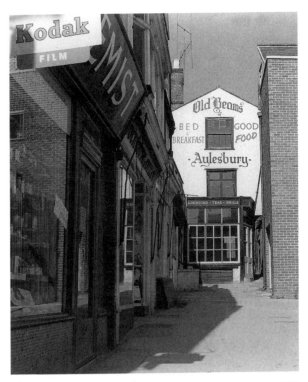

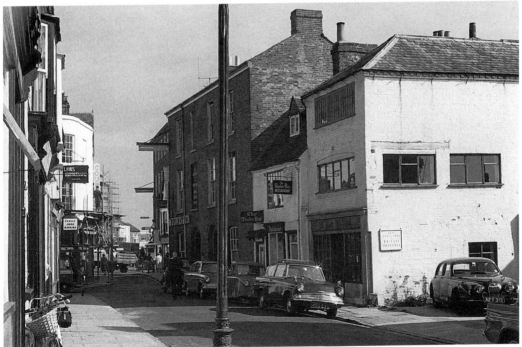

Looking down Bourbon Street, 1964. The white building on the right was for many years the offices of the Bucks Advertiser newspaper. Next door to it is the Tinder Box café. In the latter part of 1964 all of the buildings on that side of the road were torn down to make way for Friars Square. *(M. Sale)*

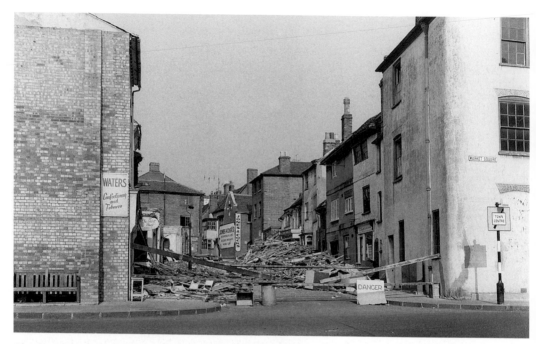

The demolition of Silver Street, 1964. This was part of the scheme to redevelop the town centre and create a new shopping area, together with car parks and bigger roads, to better serve Aylesbury's increasing population. *(M. Sale)*

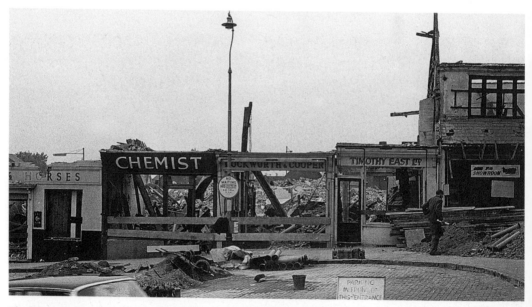

The last remains of some of the buildings in Market Square. When cleared, this area would form part of the entrance to Friars Square. Every generation that comes along has new ideas of how to improve the town. There have been so many big ideas over the years that have left their mark and Friars Square is certainly the biggest and most controversial. Centuries-old history and character was removed in one fell swoop for this development. *(M. Sale)*

Turnfurlong, 1964. A dead giveaway for the period is the car parked on the right – a three-wheeled bubble car, popular in the 1950s and '60s. This old country lane originally led to Bedgrove Farm which, at the time this photograph was taken, had been demolished to make way for a new housing estate called Bedgrove. *(M. Sale)*

Loader's corn merchant's building at the rear of the Town Hall, 1964. This building was originally built in 1865 as a covered market which at the time replaced the need for stalls in Market Square. By the early 1900s, Loader's took over the building and the market stalls returned to the square. Beyond is the cattle market leading down to Exchange Street at the bottom. *(M. Sale)*

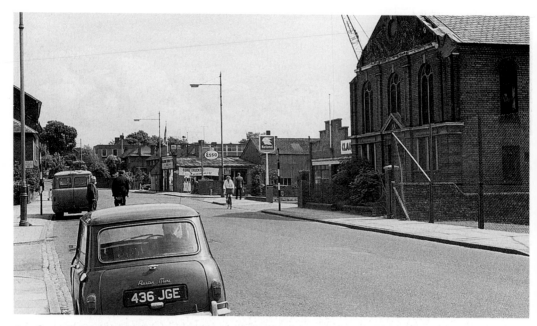

A rather quiet view of Walton Street, 1964. Normally this would be a very busy road, even in those days. This photograph was taken from outside the Ship Inn. Walton Baptist Church was at this time being stripped in preparation for its demolition – one of many places of worship to disappear from Aylesbury in the twentieth century. *(M. Sale)*

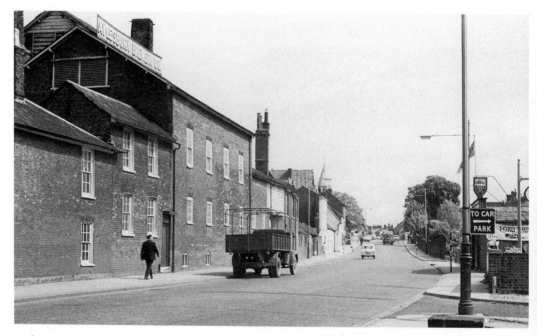

Looking up Walton Street from the forecourt of Claude Rye's garage, 1964. The imposing old buildings of the Aylesbury Brewery Company on the left were torn down the following year. The road had only recently been widened but by the end of the 1960s it would be widened yet again into the dual carriageway we know today. *(M. Sale)*

People doing their shopping on market day in Market Square, 1964. *(M. Sale)*

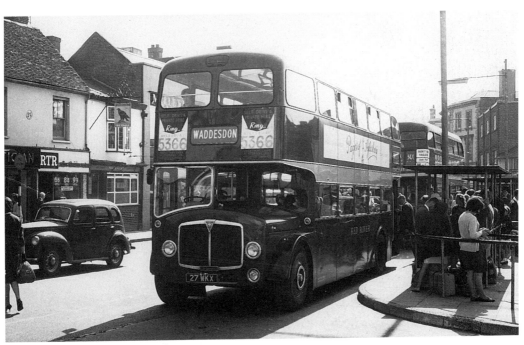

A busy Kingsbury scene, 1964. Visible here in the background on the left is the Eagle pub, which closed in 1975. It was one of the town's smallest pubs. The building still survives today and also retains its old sign bracket which is a fine piece of wrought ironwork. *(D. Bailey)*

Beaconsfield Road, 1965. This photograph was taken from the Highbridge Road end and shows building work going on for the construction of the new Aylesbury Brewery Company buildings. The buildings just past the Victorian houses on the left were part of the Technical College. *(M. Sale)*

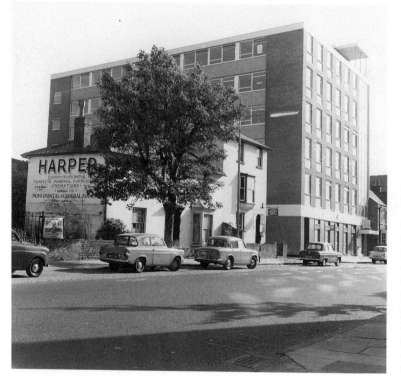

Buckingham Street, 1965. A good contrast of old and new are on show here as we see the newly built Heron House office block dwarfing everything else around it. Harper's monumental mason's yard and the row of white buildings seen here soon disappeared to become a car park. *(M. Sale)*

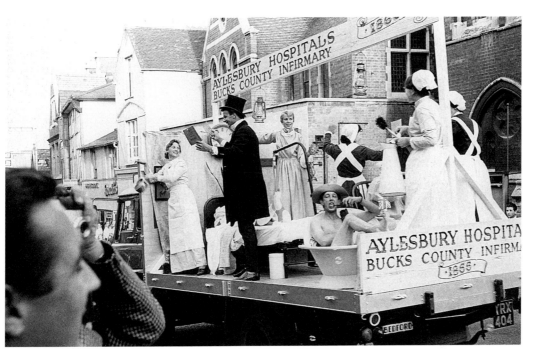

A carnival procession in the High Street during the Borough Council's Golden Jubilee celebrations, 1966. Other events included a cycle race and a concert in Market Square. *(M. Sale)*

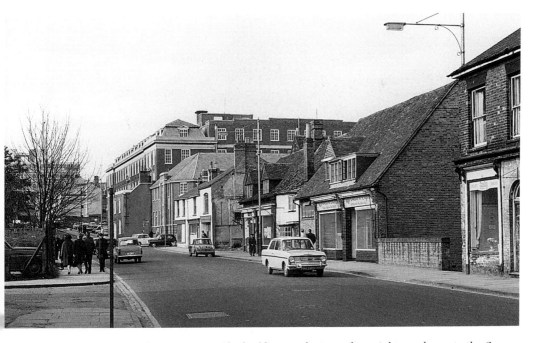

Walton Street looking towards town, 1967. The building on the immediate right was home to the Copper Kettle café. Opposite it is the entrance to Brook Street. All the buildings between the Copper Kettle and the old police garages at the end would soon be gone, to be replaced by a roundabout. *(M. Sale)*

Stalls in the cattle market, 1967. Market Square can just be seen through the arches at the top. As is shown later on, the cattle market area has been replaced by a cinema complex. *(M. Sale)*

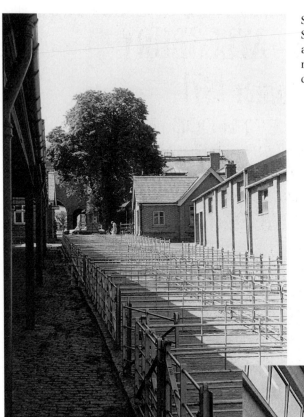

Friars Square, 1968. This is how the shopping centre looked shortly after opening. At this time the Woolworths side had not yet been completed. The market had moved from Market Square to the sunken area at the top of this slope, just below the cafeteria which is shown looming on the horizon. *(R.J. Johnson)*

FRIARS AYLESBURY
Summer 1971

Sat. June 12	FLEETWOOD MAC and Gothic Horizon	60P
.. .. 19	GENESIS and Chameleon	50P
.. .. 26	PINK FAIRIES	50P
Fri. July 2	THE FACES and a surprise...	£1★
Sat. .. 10	VAN DER GRAAF GENERATOR and...?	50P
.. .. 17	ATOMIC ROOSTER and something else!	70P
.. .. 24	an evening with QUINTESSENCE	70P
.. .. 31	EAST OF EDEN and Home	
.. Aug. 7		
.. .. 14	RORY GALLAGHER	
.. .. 21	QUIVER	
.. .. 28	OSIBISA	
.. Sep. 4	MOTT the HOOPLE	
.. .. 11	EDGAR BROUGHTON	

★ (tickets available in advance)

Some of the bands appearing at Aylesbury's Friars Club at the Borough Assembly Hall, 1971. If ever there was something to put Aylesbury on the map, this club was surely it. It was started by David Stopps after a local schoolteacher, Robin Pike, suggested the idea. The first gig was held on 2 June 1969 at the New Friarage Hall in Walton Street, and featured Mandrake Paddle Steamer and Mike Cooper. (D.R. Stopps)

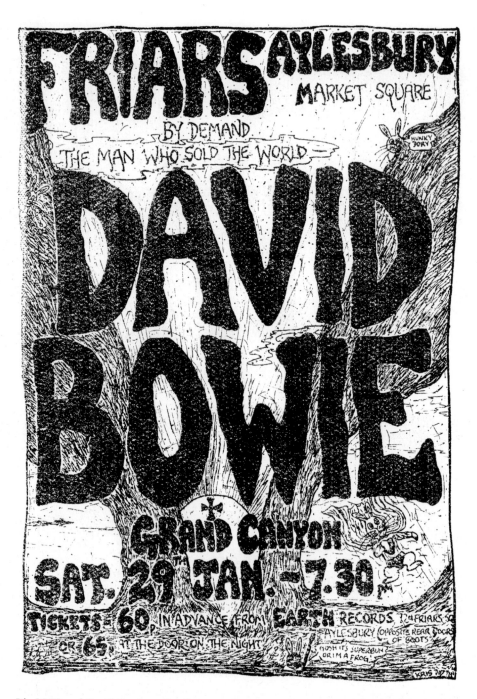

It's 1972 and David Bowie makes his second appearance at the Friars Club at the Borough Assembly Hall. He had his first concert here on 25 September 1971. Later that year he appeared along with other artists such as Lou Reed, Roxy Music, Genesis and Wizzard . . . the list goes on. Some of the foremost musicians of their day were featured at Friars, making it a legendary place to be. (D.R. Stopps)

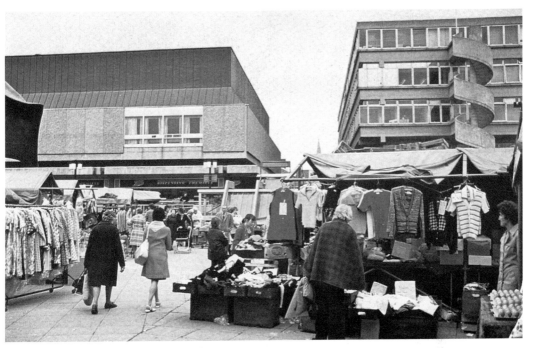

Market day in Friars Square, 1973. The shop facing us to the left is Boots the Chemist. In 1983 they moved to their present site in Hale Leys Shopping Centre. *(R. Adams)*

Sports day at Elmhurst Infant School, 1973. On the day large rubber mats were provided for the children to sit on, and in the sunny summer weather they used to get very hot. Each class was labelled with different animals such as lions and elephants. *(K. Vaughan)*

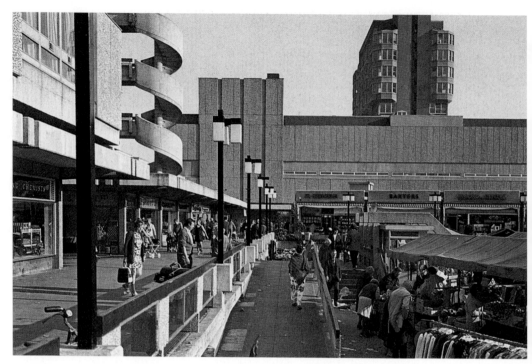

Another view of Friars Square, 1973. Here we see the completed Woolworths section of the square stretching across the back with the County Offices towering behind it. The photograph also shows where the market ended up. It was here in Friars Square until 1991 when, during the square's modernisation, it moved back to Market Square. *(M. Sale)*

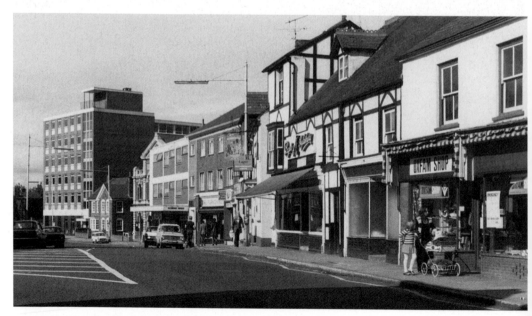

Looking down Buckingham Street, 1974. Page's the baker is seen on the right and further down the road is the large office block of Heron House. *(M. Sale)*

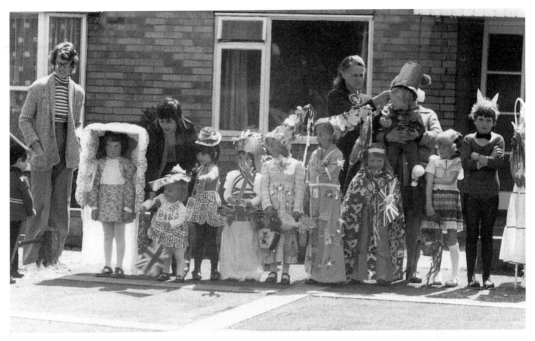

Children in Priory Crescent dressed up for the Queen's Silver Jubilee of 1977. *(R. Adams)*

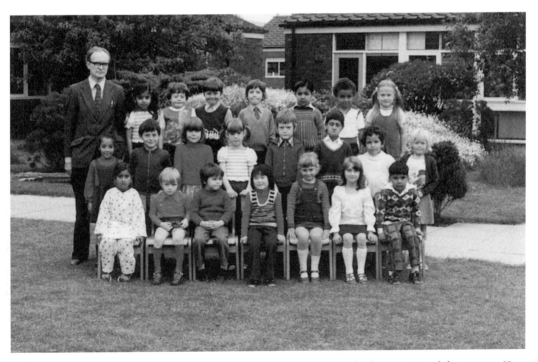

Earlier in this book we have seen a couple of school photographs from the first quarter of the century. Here is one from Elmhurst Infant School in 1977. The teacher was Mr Norwood, and the boy with the zipped cardigan just right of centre in the middle row later became an author of books about Aylesbury (including this one). *(K. Vaughan)*

David Stopps pictured with
Phil Collins and Peter Gabriel
on 24 August 1979 at the
Friars Club. Peter was doing
a concert at the time and
Phil turned up unexpectedly
to play African drums and
congas. The photograph was
taken by Armando Gallo. In
1970 Peter Gabriel broke his
ankle at a Genesis concert
here. During the show he leapt
off the stage into the crowd
hoping they would catch
him. To his surprise they just
parted and he fell to the floor.
He was subsequently taken
to the Royal Bucks Hospital.
To this day, Peter still gets the
odd twinge from his ankle –
a constant reminder of his
days at Friars. Genesis made
a number of appearances at
Aylesbury, their last gig being
on 22 March 1980. The last
concert at Friars was on
22 December 1984 and
featured Marillion. Its closure
was headlined in the *Bucks
Herald* as 'The Day the Music
Died'. *(D.R. Stopps)*

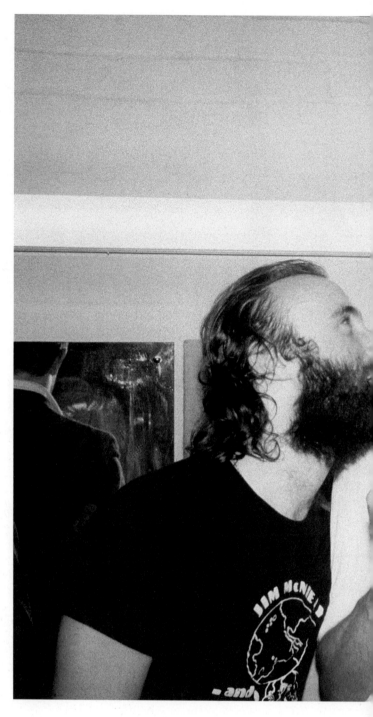

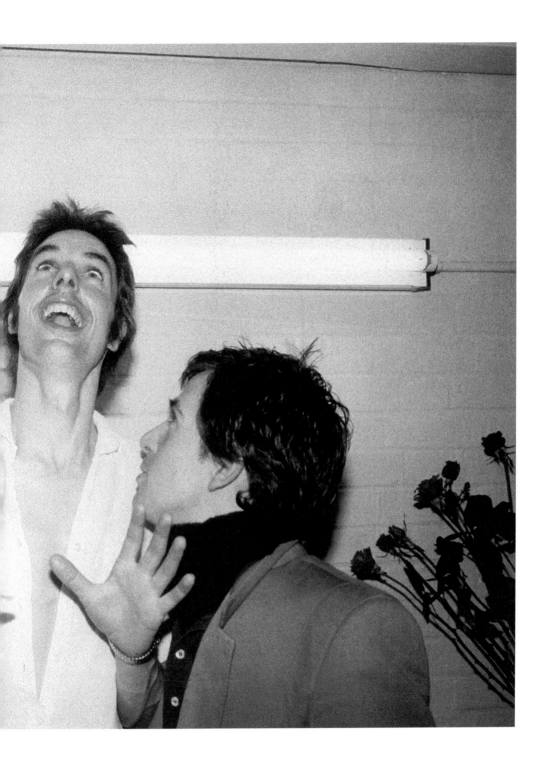

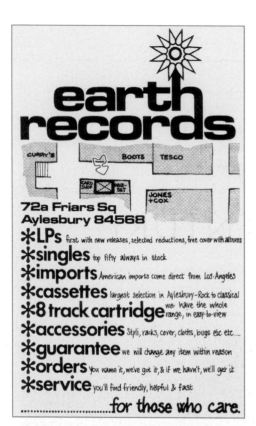

An advert for Earth Records in Friars Square. The shop was run by David Stopps and was the place to buy tickets for various Friars concerts. It was also a great place to get those hard-to-find records. *(R.J. Johnson)*

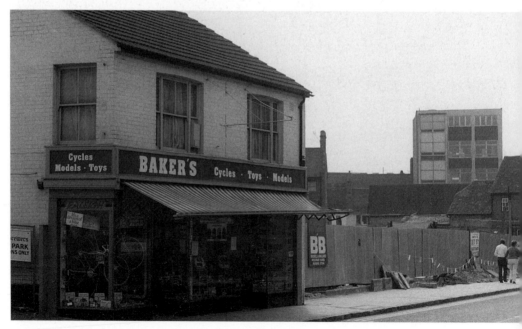

Baker's cycle and toy shop in Buckingham Street, 1979. Next to it Chamberlin's motor engineers site has been cleared in readiness for the construction of Sainsbury's supermarket. *(R. Adams)*

5

THE 1980s TO THE END
OF THE CENTURY

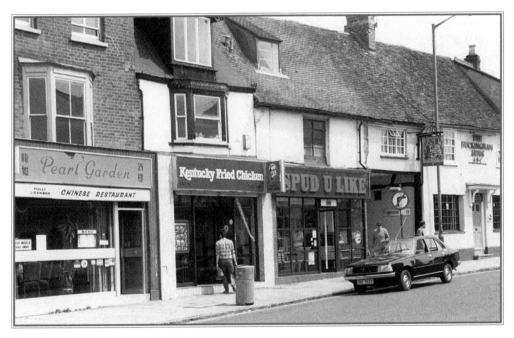

Shops in Buckingham Street, June 1984, indicating the variety of fast food that we have all come to expect. *(R. Adams)*

FRIARS

PRESENTS LIVE ON STAGE
AN ORIGINAL FRIARS AYLESBURY LEGEND

GENESIS

TONY BANKS PHIL COLLINS MIKE RUTHERFORD

Saturday, 22nd March. 7.30 p.m.

MAXWELL HALL, MARKET SQ., AYLESBURY

This Ticket Value 350p (including VAT)

Friars Aylesbury is a Club and therefore it is essential that Membership Cards are produced on the night even if an advance ticket has been purchased. If you are not a member, membership must be obtained on the night. Minimum age for membership is 16 years. Life Membership is 25p (including VAT) Thank you.

A ticket for the final concert that Genesis played at Friars on 22 March 1980. This was arguably the biggest gig ever held at the club. Tickets first went on sale on a cold Sunday morning in February. The queue for tickets started on the Friday and people were even camping in the cattle market, which just shows what a major event this was at the time. (D.R. Stopps)

High Street, 1980. Here we see the former Congregational Church pictured shortly before work started on its demolition for the construction of Hale Leys Shopping Centre. The church tower was retained and integrated into the main structure of the centre. (R. Adams)

The main entrance to the Borough Assembly Hall, 1980. This hall was at the rear of the Green Man pub in Market Square. During the 1950s and '60s it was known as the Grosvenor which was a music venue as well as being a popular roller skating rink. *(D. Bailey)*

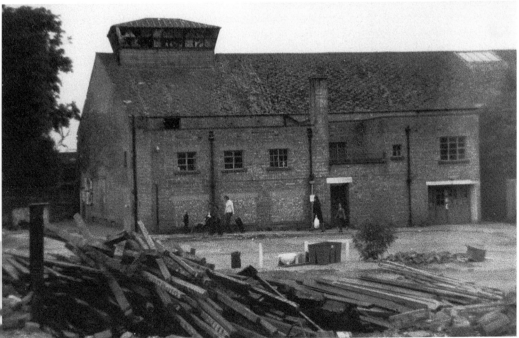

Here we can see the full extent of the Borough Assembly Hall. This is viewed from the temporary car park that was left after the demolition of the Bull's Head Hotel. Hale Leys Shopping Centre would soon be started and this large hall was demolished in the development. All major music events had since moved to the new Civic Centre, which opened in 1975. *(D. Bailey)*

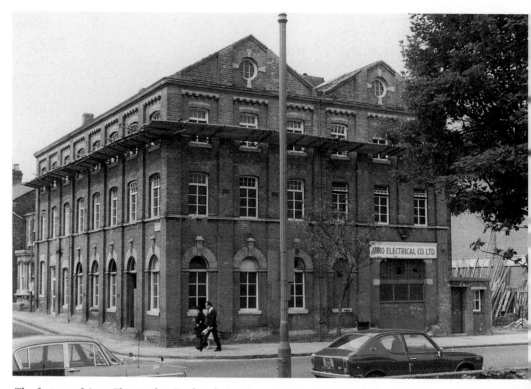

The factory of Agro Electrical in Buckingham Street, March 1980. This large Victorian building stood at the bottom of Granville Street and was originally built as a bakery. Later it became home to the printing firm of Hunt Barnard. Now an office block stands on the site. *(R. Adams)*

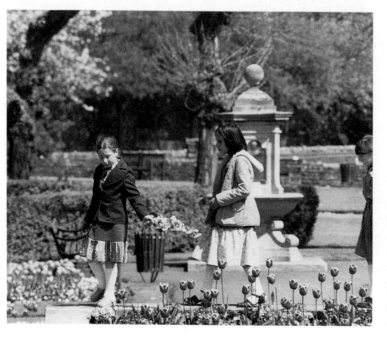

Some girls wandering through Vale Park, May 1980. Just behind the girl in the middle is the drinking fountain that was moved from Kingsbury in the 1920s and is seen earlier in the book. *(R. Adams)*

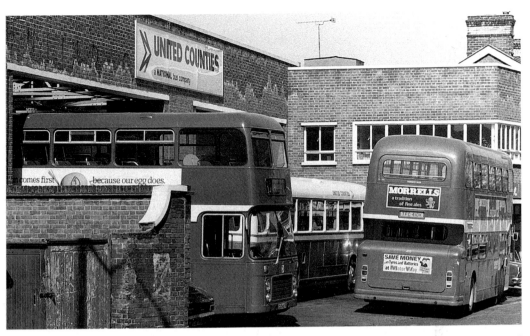

The United Counties bus depot, May 1980. This was opened in 1949 and was built on the site of a row of cottages in Granville Place. The whole area has since been cleared and some new apartments have been built. *(R. Adams)*

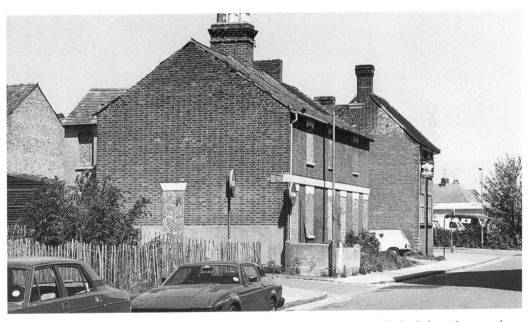

A view down Railway Street, May 1980. The cottages seen here were originally built for railway workers. Aylesbury's first railway station used to stand at the end of this street, hence its name. It was established in 1839 and in 1889 a better site was found in the High Street. This new station was demolished in the early 1960s. The pub seen on the corner is the Prince of Wales, which has also disappeared. This whole block is now occupied by a multi-storey car park. *(R. Adams)*

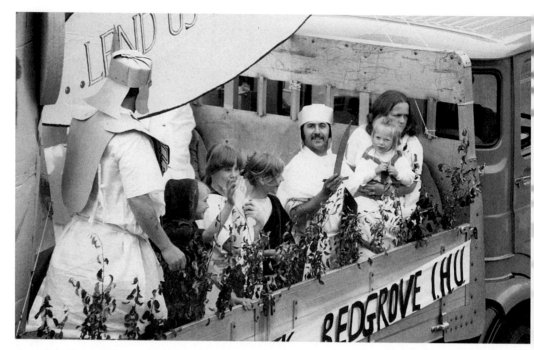

One of the floats in the carnival of July 1980. These floats would parade through the town and finally end up at the Edinburgh Playing Fields on Churchill Avenue where there was a fair. *(R. Adams)*

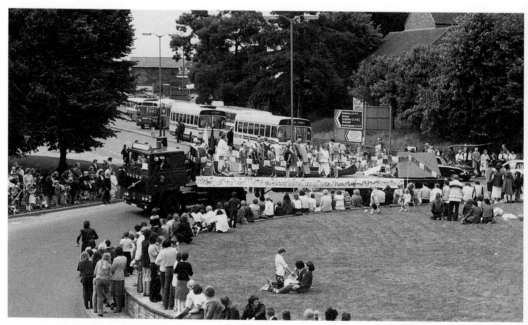

A carnival float going round the roundabout in Friarage Road. This had already travelled up Buckingham Road, Buckingham Street and into Market Square. On their way up the road, some people on the floats would throw jam doughnuts in bags to waiting children on the road side. It has been many years since Aylesbury has seen a carnival like this. They were something to look forward to every year. *(R. Adams)*

A building at the bottom of Nelson Terrace and Whitehall Street, August 1980. Behind it was the builder's yard of George Adams. It was demolished in 1982. Prebendal Court now stands on the site. *(R. Adams)*

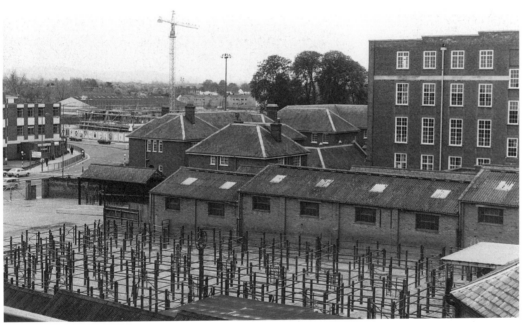

A view over the cattle market, May 1981. This was taken from the Civic Centre car park and in the distance work has begun on the building of the new Equitable Life office block known locally as the Blue Leanie. The cattle market closed in 1987 and the area became a car park. The Odeon cinema complex now stands on the site. *(R. Adams)*

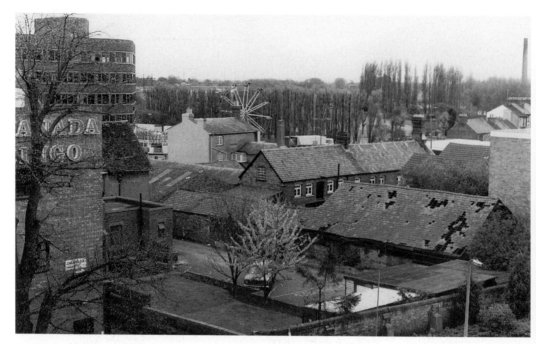

Another view from the Civic Centre car park, May 1981, this time looking towards the Vale Park with buildings at the rear of the White Hart and Chandos Hotel in Exchange Street in the foreground. Looking beyond these buildings there appears to be some sort of fair going on next to the Vale Park. *(R. Adams)*

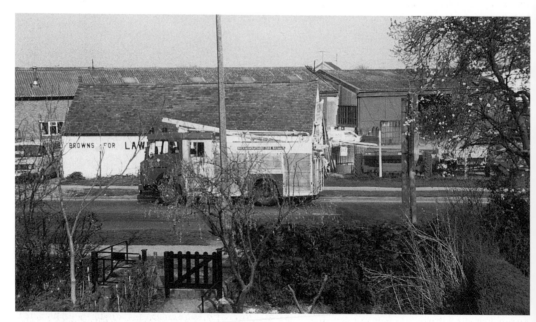

A fire engine outside Browns in Buckingham Road, 1981. As well as selling lawnmowers, Browns were also sellers of agricultural machinery, which is seen on display to the right of the white barn. The car showrooms of Dutton Forshaw later took over this site, and it is now used as a forecourt. *(K. Vaughan)*

Pages of Aylesbury's bakery in Buckingham Street, May 1981. They closed in about 1984 and these buildings were demolished shortly afterwards to be replaced by shops and offices. *(R. Adams)*

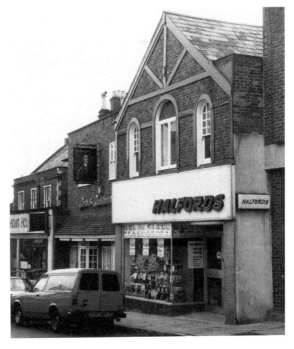

Halfords cycle shop in the High Street, September 1982. Next door is Hampdens bar and restaurant. Shortly after this photograph was taken, Halfords moved up the street to premises next to W.H. Smith. *(R. Adams)*

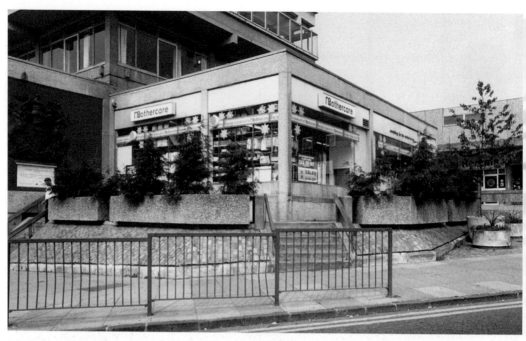

Mothercare in Friars Square, September 1982. This fronted Market Square and was one of the first shops to move here when the shopping centre opened in 1967. *(R. Adams)*

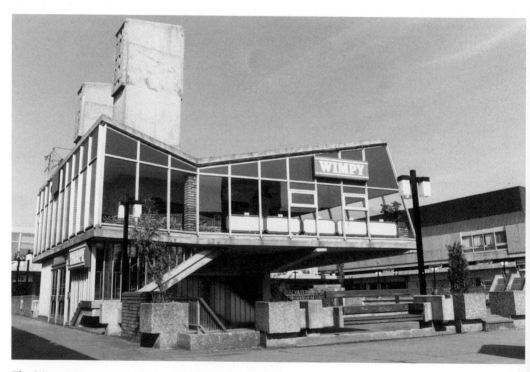

The Wimpy restaurant in Friars Square, 1983. The entrance was through some double doors which are seen on the left. They also led to the underground market. *(R. Adams)*

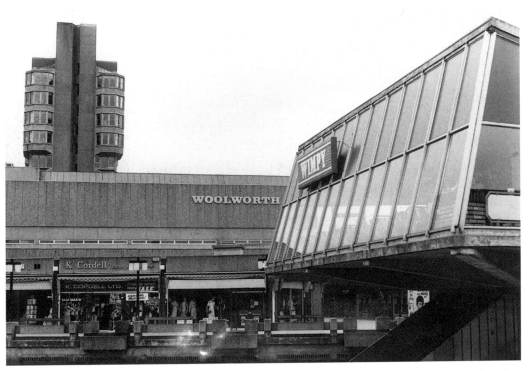

Another view of Friars Square, 1983. The Wimpy is seen again on the right and beyond is Woolworths, which occupied three floors and opened in 1969. It had a food hall on the ground floor, sweets, magazines and records on the first floor, and household items and a restaurant on the second floor. *(R. Adams)*

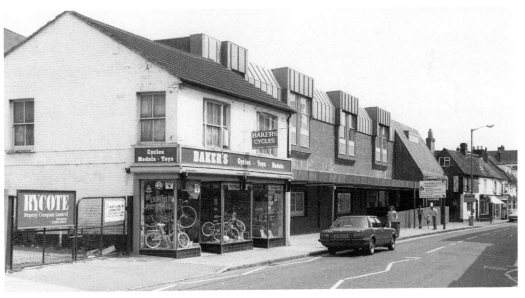

Looking up Buckingham Street, June 1984. Sainsbury's supermarket can be seen next to Baker's cycle and toy shop. At the very end of the street is the Harrow and Barleycorn pub. *(R. Adams)*

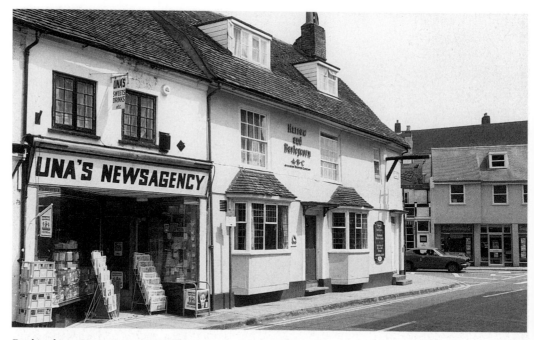

Buckingham Street, June 1984. The pub seen here had recently been refurbished. It was a combination of two pubs, the Harrow, and the Barleycorn, which was round the corner in Cambridge Street. To join the two a new entrance was built. Around ten years later it was renamed the Farmyard & Firkin. This was short-lived as it is now known as just the Harrow. *(R. Adams)*

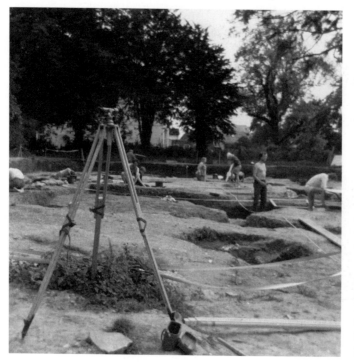

The excavation in July 1985 of a piece of ground behind the Prebendal near St Mary's Church. The dig lasted through the summer and many discoveries were made, including part of an Iron Age ditch which once encircled the hill that Aylesbury stands on. Evidence of this ditch has been found in other parts of the town which leads experts to believe there was once a hillfort here. *(K. Vaughan)*

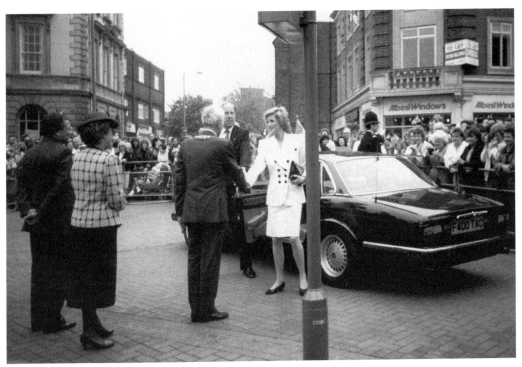

Diana, Princess of Wales, visiting Aylesbury on 25 May 1989 after having been to the Springhill Centre at Dinton. About 2,000 people gathered in Market Square to greet her. *(G. Dilleyston)*

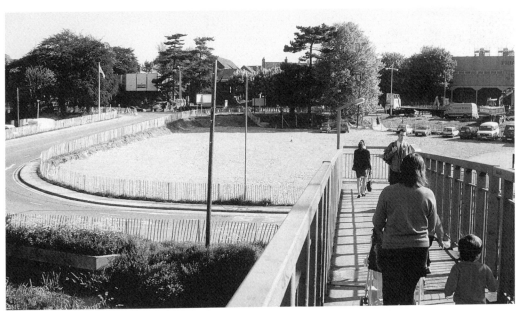

A view towards Friarage Road from the railway bridge, 21 May 1991. The road curving on the left is Station Way. The grass had recently been stripped from the area below and became a temporary car park while the new Safeway supermarket was being built. *(K. Vaughan)*

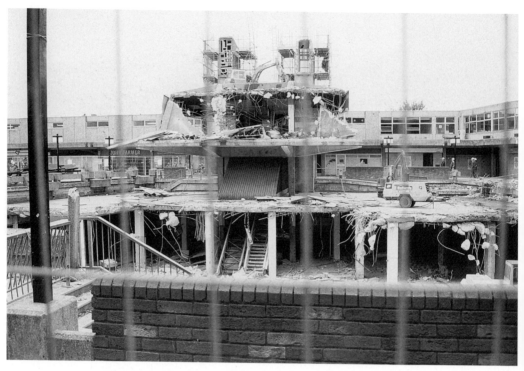

The refurbishment of Friars Square, 29 May 1991. The old Wimpy restaurant is seen here being demolished with the underground market below. This would later be covered over again. *(K. Vaughan)*

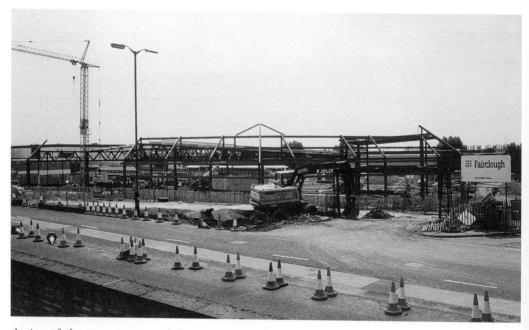

A view of the superstructure of the new Safeway supermarket, 27 July 1991. Friarage Road is in the foreground. *(K. Vaughan)*

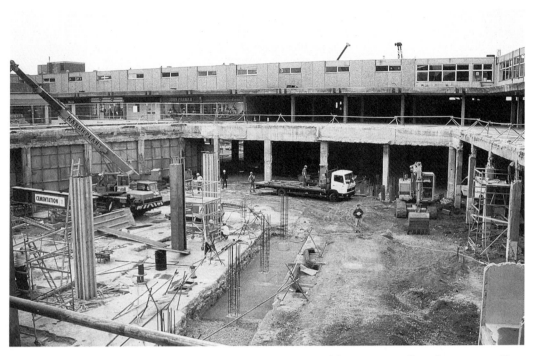

Friars Square, 12 September 1991. With the old Wimpy gone, work began on installing the concrete pillars to support the new steel floor. When complete, this area would be used for a handful of shops and places to eat. *(K. Vaughan)*

While work was going on with the refurbishment of Friars Square, I was able to take this photograph looking down Silver Street, 12 September 1991. It was a rare chance to see the whole length of the street again. Taken from Bourbon Street, this shows the Bell Hotel in Market Square appearing through the gap by the skip. This gap was eventually closed up again when the refurbishment was complete. *(K. Vaughan)*

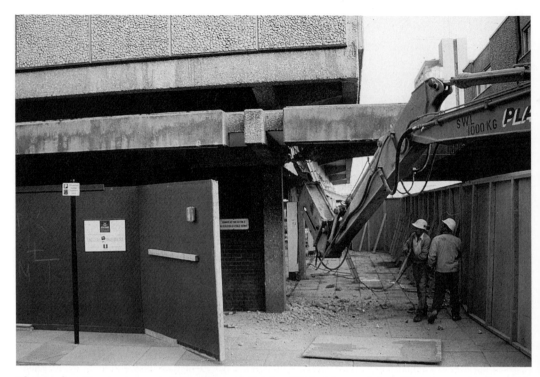

The Bourbon Street entrance to Friars Square, 1 October 1991. A heavy-duty drill is being used to demolish part of the structure. It certainly made the ground shudder when in use. *(K. Vaughan)*

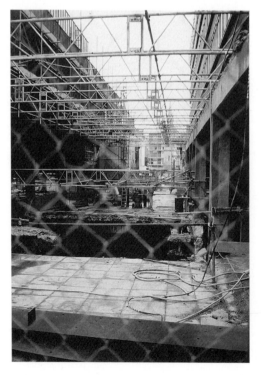

Friars Square, 14 November 1991. Work has progressed a bit further now: a hole has been created for the installation of the escalators, which would eventually lead down to the Cloisters shopping area. *(K. Vaughan)*

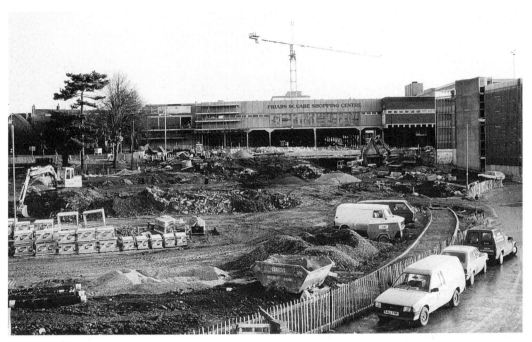

Friars Square viewed from the railway bridge, 15 February 1992. In the foreground work has begun on the new car park for the Safeway supermarket nearby. The crane on the horizon was erected in the middle of Friars Square to help in the construction of the new roof. *(K. Vaughan)*

Cambridge Street, 14 December 1992. The Oddfellows Arms pub later closed and became Domino's Pizza. Opposite the old pub were various buildings including another pub, the Nag's Head, which were cleared to make way for Upper Hundreds Way. *(K. Vaughan)*

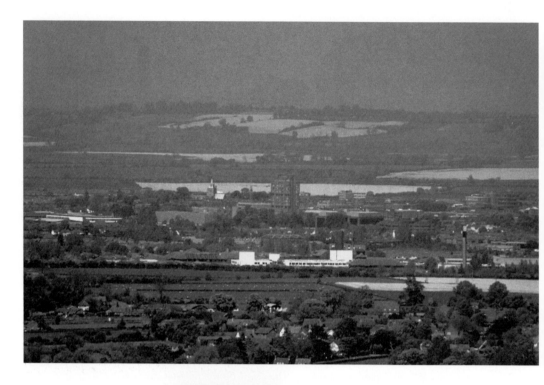

Aylesbury seen from Coombe Hill, Wendover, 17 May 1992. Ever since 1966 the town has been dominated by the large office block that is the County Offices. St Mary's Church, which has stood proud for around 800 years, is now dwarfed by it. This view shows well the wonderful Vale of Aylesbury – a rich and fertile part of the county. What a shame it is slowly being encroached upon. *(K. Vaughan)*

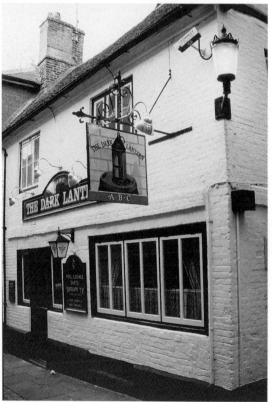

The Dark Lantern in Silver Street, 1993. This pub remains as the only original building on that street. Others have been rebuilt and the rest has been obliterated by Friars Square. *(K. Vaughan)*

Hasberry's DIY shop in Temple Street, 1993. After serving the town for over fifty years, Hasberry's has since closed. *(K. Vaughan)*

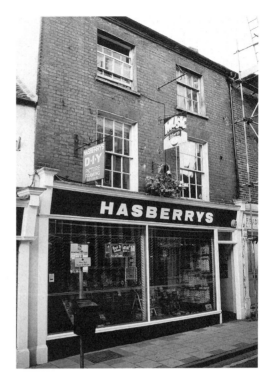

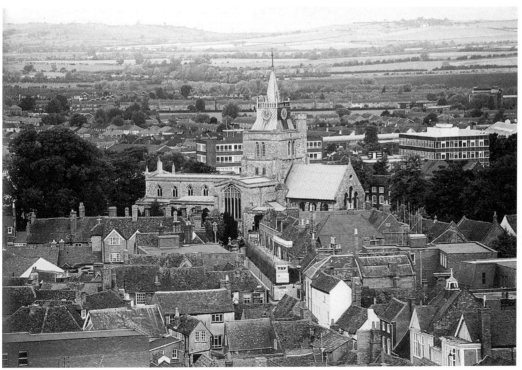

A view over the older part of town taken from the County Offices, 11 September 1993. Surrounding St Mary's Church are the medieval streets and houses that form part of a conservation area. *(K. Vaughan)*

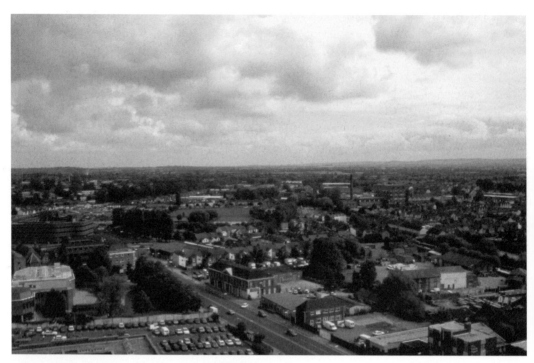

Exchange Street area, 11 September 1993. Just right of centre is the Nestlé factory with its chimney. This was dismantled in October 1994. *(K. Vaughan)*

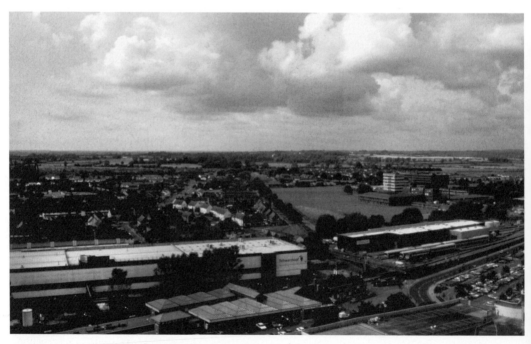

Looking south-west across Aylesbury, 11 September 1993. The Schwarzkopf factory has since been demolished and replaced by the Grand Junction apartment complex. Aylesbury College (right of centre) has too been demolished and replaced by modern buildings. *(K. Vaughan)*

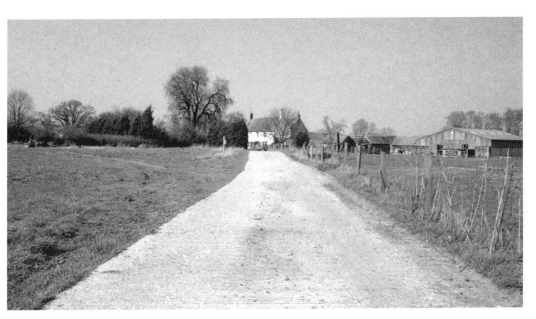

Coldharbour Farm, 2 April 1995. At the time this photograph was taken, planning was already underway for a new mini village called Fairford Leys. Amazingly the old farmhouse was kept and is now surrounded by houses. *(K. Vaughan)*

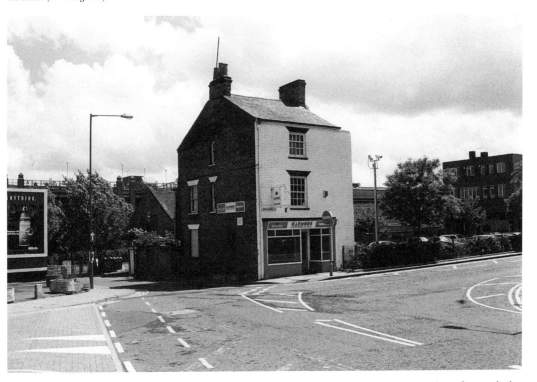

A view of Station Street, 8 June 1997. The building seen here fronting Britannia Street (together with the one behind it), was demolished in May 2000 to make way for two large stores. Station Street itself also disappeared at that time. *(K. Vaughan)*

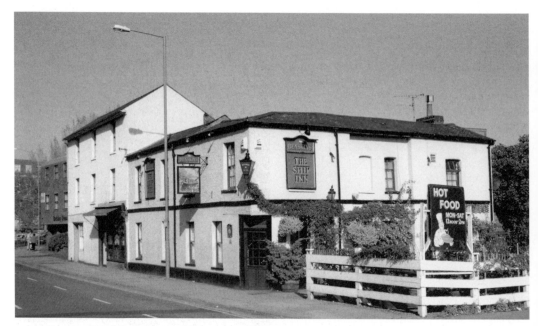

Jackson's Bakery and The Ship Inn on Walton Street, 19 October 1997. These buildings survived well over the years. Much change has happened around them. They survived the 1960s with all the major redevelopment of the town but alas they would not see much of the twenty-first century. As part of the Waterside scheme they were both demolished in 2008. *(K. Vaughan)*

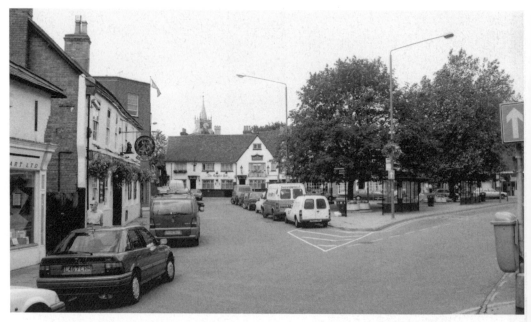

Kingsbury in 1997. The central island with bus shelters and underground toilets were swept away in the modernisation of the area in 2004. Much of the roadway was replaced by paving and a controversial water feature was installed – controversial because it leaked quite badly soon after its opening. With the problems overcome, this area is now a popular place to eat and enjoy various public events. *(K. Vaughan)*

A view of Market Square, 9 May 1998. This was a special day in the town as a few noted buildings were open to the public – the County Offices being one of them. People were allowed to go up to the very top to see a fine view of the town and its surrounding countryside. In this particular view the Bell Hotel is visible below, and in the distance is the dry ski slope at Watermead. *(K. Vaughan)*

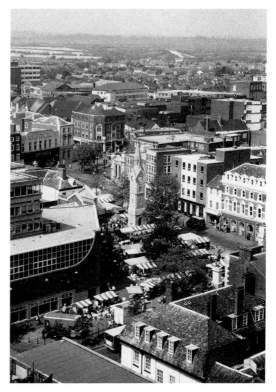

The Nestlé factory, 29 May 1998. This was a familiar landmark in the town throughout the twentieth century. It stood until 2006 when it was sadly demolished and replaced with apartments. *(K. Vaughan)*

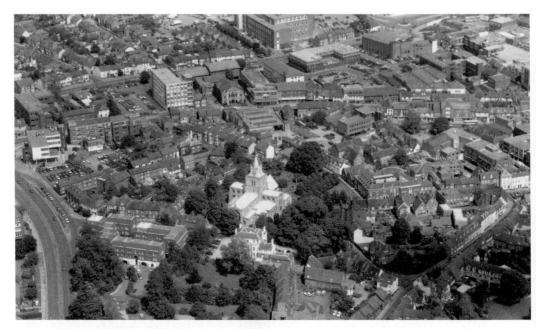

A view over the oldest part of the town on 29 May 1998. Oxford Road is on the left with Castle Street running diagonally to meet Temple Square on the right. *(K. Vaughan)*

Another view of the town, 12 June 1998. This was taken from the factory block of Nestlé and shows the Queen's Park estate below. At the very bottom are houses on the High Street. *(K. Vaughan)*

During 1998 some old buildings at the junction of Kingsbury and Buckingham Street were refurbished. When the structure was stripped back and the ground in front excavated, this interesting feature appeared. Cut into the natural bedrock is the ancient ditch that once encircled the hill where Aylesbury now stands. This ditch is about 2,000 years old. *(K. Vaughan)*

The car park on the site of the old cattle market, 2 August 1998. This was taken a day before work was to begin on the construction of the new cinema complex. *(K. Vaughan)*

Another view of the car park, 2 August 1998. Seen on the right is the old wall that stretches right down to Exchange Street. It used to be the boundary wall of the old White Hart Inn that stood in Market Square until 1864. To the rear of the inn were extensive grounds with orchards, gardens, a bowling green, kitchens and stables. *(K. Vaughan)*

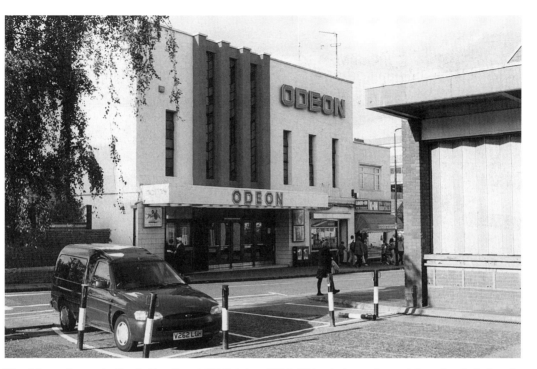

The Odeon cinema in Cambridge Street, 27 October 1999. This photograph was taken shortly before its closure when the new cinema was built in Exchange Street. The building still survives, although in a rather neglected state as it has been unoccupied since it closed. *(K. Vaughan)*

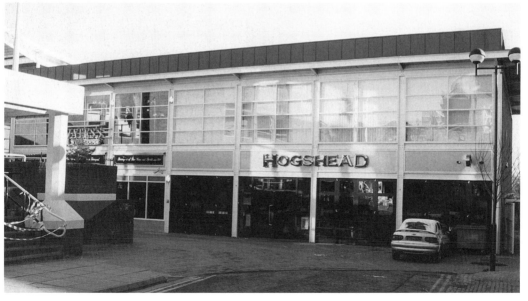

The new Hogshead pub, 19 December 1999. Next door to the left is another pub, Yates's Wine Lodge. These are both part of the cinema complex, which is seen on the next page. On the left are steps leading to the Civic Centre. After only eight years of operating, the Hogshead changed into the Slug & Lettuce in 2007. Yates's has since become La Tasca. *(K. Vaughan)*

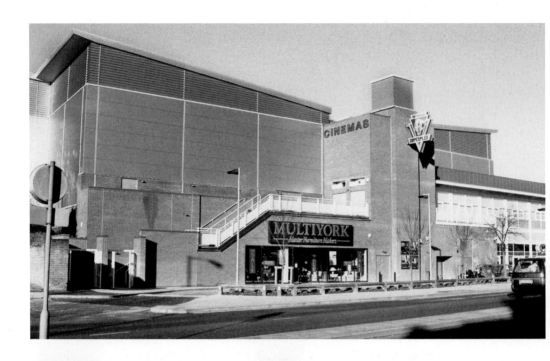

The newly built ABC cinema viewed from Exchange Street, 19 December 1999. Early in 2000 the building was taken over by Odeon cinemas. *(K. Vaughan)*

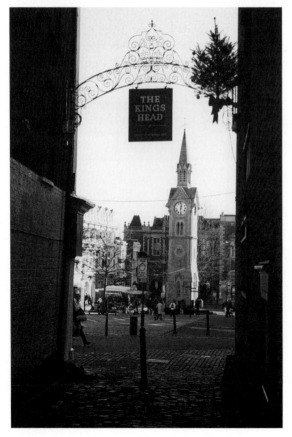

And so we reach the end of the century. A lot has changed in that period and many things still remain the same – like this view of Market Square taken on 19 December 1999 from the entrance to the King's Head, Aylesbury's oldest inn. Now the square has been pedestrianised it is comparatively safe to walk about without worrying too much about traffic, not unlike how it was in 1900. The Market Square seemed the appropriate place to be on Millennium night. It was raining near midnight and there was a brief fireworks display. I stood there thinking of all the years that have passed, wondering what the people of the town were thinking when they stood there at the turn of the twentieth century. I wonder what changes the twenty-first century will see? *(K. Vaughan)*

ACKNOWLEDGEMENTS

I would like to thank the following people for their help and support during the compilation of this book. Richard J. Johnson for lending me some of his fine postcards and his insight into the history of the town. He also helped me find the amazing photographs of the Walton parachute mine damage which are deposited at the Record Office and form part of the Hazell, Watson & Viney scrapbook. Permission for their use was given by the late Elliott Viney and I am very grateful. Also thanks to David Bailey for the use of his postcards and photographs. Also thanks to Peggy Sale for letting me use her fine photographs and postcards. I must also thank my uncle, Ron Adams, for digging out some useful photographs for the 1980s section – I would have been lost without them. I thank the late John Millburn for the use of the fine photograph of his old auction rooms on page 64. To David Stopps for being so very helpful with information and memorabilia concerning the Friars Club of the 1970s and '80s. It made very interesting reading. And finally to Gary Dilleyston for his photograph of Diana, Princess of Wales.

Also available from The History Press

Aylesbury Remembered
KARL VAUGHAN

Aylesbury Remembered covers the 100 years between the 1830s and the 1930s, during which time the town expanded enormously. With a multitude of views, some very rare, the book displays demolition and redevelopment, as well as the railways, canals, roads, shops, houses and, most importantly, the people who made Aylesbury what it is today.

978 0 7509 3923 0

WANT TO KNOW MORE ABOUT AYLESBURY?

Started in April 2008, Aylesbury Remembered is a Facebook group for anyone interested in Aylesbury's past or for sharing memories and photographs of times gone by. When the group started there were only a handful of members. It wasn't until Christmas 2009 that the group became very popular. All of a sudden there was a massive influx of new members and by the beginning of 2010 it caught the attention of the *Bucks Herald* newspaper which featured a whole page about the group. Since then it has grown even bigger and because of the broad appeal of Facebook, the group has members from all over the world – from New Zealand to the USA. This means that members can contact people they haven't heard of for many years. It has really turned into something special. You can visit the group at:
www.facebook.com/group.php?gid=13002872097.

Visit our website and discover thousands of other History Press books.

www.thehistorypress.co.uk